This book is dedicated to:

the wildlife of planet earth

without them we would have
no careers,
no inspiration,
and no future.

Contents

Acknowledgements

Many thanks to all the contributors in this book who gave of their time and wisdom freely – their details can be found in the contributors' index at the back of the book.

I would also like to thank: Jeffery Boswall for his foreword, advice and information, Roland Clare for proof-reading and editing, Bryan Smith for supplying advice from his book Desperately Seeking Screentime, Jeremy Evans for suggestions, Danny Bamping for enthusiasm.

Foreword

by Jeffery Boswall
Wildlife Television Training

You want a career in wildlife film-making? Then acquire and read - but most importantly - act on this book. It will really help you. Getting work in nature moving-imagery (whether for films, television, school/university video, home video, multimedia or the internet) is hard work. The business is competitive, currently even more so than five years ago. But as I say to students: it may be a marathon with a vast entry, but someone has to come first, second, third and so on. Why not you? This volume helps plot the 26 mile route.

People already in the industry, I feel sure, will also be glad to have this volume, or at least to dip heavily into it. They too can learn some new things, if only how widely and deeply held some views are held, and some understandings understood.

I've been in this business since 1957. I try hard to keep up, attending the big festivals in the UK (one) and the US (two), listening to the many visiting lecturers on my courses, reading Mark Bristow in BBC Wildlife, viewing many programmes ... but this book has brought home to me some important realisations beyond my previous cognisance. The forty-odd contributors to the volume, many from a younger generation, write from individual experience, from a variety of job-positions, sometimes from rather different philosophies, but always with personal authority and conviction (and sometimes humour).

Having taught this subject since about 1988 (when Peter Bassett helped me run the very first course – *Cine Verde* – in Rome), I've challenged students, and they've challenged me, scores of them, hundreds of times. I am tempted to hijack this preface and urge upon you selected aspects of the advice herein – my hobby horses. Particularly: the need for fine story telling, good (succinct) and economic programme proposals, short CVs, brief show-reels displaying a clear understanding of filmic-grammar, active networking and full prior research of any organisation and any person you apply to for work-experience or work.

It's all in this book, and much more. If you put it to work for you, this volume can do much for you – and thus, longer term, for the profession. It is a great profession, be in no doubt: free travel, some glamour, immense satisfaction, great rewards and (possibly) some money. Above all, it is an opportunity to enrich, by a fraction, the lives of the people who will see your work.

Introduction

A Career in Wildlife Film-making. An attractive proposition indeed – and a challenge too!

Let's start by picking apart the title:

A **Career** in Wildlife Film-making. By 'career' we mean spending your working life, or part of it, working in this industry. You may be employed or freelance or a combination – and it may also mean that you spend part of your time working outside this industry in order to survive. These days it pays to be flexible, adaptable and multi-skilled!

A Career in **Wildlife** Film-making. Your first thoughts may be of herds of wildebeest on the plains, or jaguars in the rainforest – but in this book we are also talking about underwater wildlife, conservation, and other kinds of animal programmes. The extent to which the theme of your work varies depends on your actual job and who you work for. If you specialise in filming in rainforests for example, you may be lucky enough to spend much of your time doing just that, but if you are a picture editor you may be working on a shark documentary one day, and a programme about a zoo vet the next.

A Career in Wildlife **Film**-making. Although we nearly always refer to wildlife films – we are talking mostly about production for TV. Having said that, there are occasional wildlife films that have been successful in the cinema – the lovely French bug film *Microcosmos* is a reasonably recent example, and many of the early Disney wildlife films were produced for public cinemas. Also note that we refer to wildlife films even if they were originally shot on video and have never seen photographic film.

A Career in Wildlife Film-**making**. The aim of this book is to look at the career of every person involved in the making of a wildlife film. It's true that a few films are made in their entirety by one person, but more usually it is a team effort, and some of the big productions/series can involve large teams! So we are not looking just at the sharp end of the wildlife camera operator, but also at everyone involved in the production process.

Why is it a challenge?

• Because it's an attractive thing to do, there are far more people wanting to be involved in the making of wildlife films than there are jobs, so it is very competitive. This is the same, however, for many enticing careers – so if you've got what it takes you can rise above the rest!

• There are far more film ideas, and people and production companies making wildlife films, than can be broadcast (apparently Discovery get 6,000 new film proposals each year!). The majority of proposals are rejected, and some films are made which do not get broadcast, or do, but still make a financial loss. It can be a hard business, and one of the hardest parts is getting commissions accepted. Bear in mind, though, that these days broadcasting is not the only final destination for a film.

• The wildlife film industry is currently going through changes which makes the whole situation more unstable. For example, nearly all of the staff of Survival – the world famous production company based in Norwich UK – found themselves without jobs in 2001 when the company name was suddenly 'moved' to Bristol after a merger with Granada Media.

Still, if you're up for a challenge – read on!

Why is the industry changing?

The main root reason is that with the recent growth of satellite and cable television, viewers simply have a wider choice and so are more thinly spread. Fewer viewers per programme (known as a smaller *rating*) means smaller production budgets. Smaller budgets can mean poorer quality films – a potentially dangerous downward spiral – but here is where one of the new challenges lies: make better films for less money!

You might think that with the arrival of channels like Discovery's Animal Planet and National Geographic, there is much more demand for wildlife films. To a certain extent it is true that more films are being made as a result, but again with smaller budgets – and always ratings-conscious. Increased viewers' choice makes the ratings war much more competitive, which leads broadcasters to follow successful trends, proven stereotypes. At the moment (2002), for example, programmes with hands-on presenters wrestling with crocodiles are more popular with the public than classic 'blue-chip' programmes.

By the way – 'blue-chip' is an expression you'll hear a lot in this industry. Blue-chip films are generally high-quality, big budget programmes or series, produced by bigger production companies such as Survival or the BBC. Although beloved by many, and in their time achieving good ratings, blue-chip films now struggle to make a profit. There are a few exceptions, however, notably the success of *The Blue Planet* – the BBC's recent big budget series.

Another reason for the changes in the industry is that digital video technology has introduced a host of new camera equipment that is much more affordable than film cameras. This may seem like an answer to the challenge 'make better films for less money', and it is true that video-originated productions can be much cheaper than film-originated ones; but they are not necessarily of such pictorial quality.

There do appear to be quite a few doom-merchants in the wildlife film business at the moment – especially established people who are suddenly struggling. But I do believe that, as with anything else in life, you need to tackle change with positivity and learn from what is happening around you.

The future of the industry is discussed in much more detail in a later chapter in this book, with personal views from a wide variety of professionals currently working in it.

How can this book help you?

Essentially by giving you a deeper understanding of the wildlife film industry and the career opportunities available.

How a Wildlife Film is Made – gives a brief overview of the whole process from idea to viewer, plus an introduction to formats.

The Variety of Jobs – describes each of the jobs involved in the process, and a few associated careers too. These can be employed positions or freelance ones, and each is illustrated with a number of case studies.

How to Get Started – strategies and tips to get your foot in the door.

Education and Training – what courses are available, and how useful they are.

Wildlife Film Festivals – a discussion of festivals and why they are particularly important in this industry, plus a directory of the major international ones.

Organisations, Projects and Further Information – where to find out more, organisations that might help you, and recommended further reading.

The Future of the Industry – a unique discussion of the future presented by a number of experienced professionals from the industry.

Contributors' Index – a list of all the contributors to this book – with further information and contact details.

Note that this is an international book, with contributors from all over the world: you may notice that different countries spell some words in different ways – color/colour, organize/organise for example. I have left the spellings true to the contributors' origins. Also note that since the book was first published in 2002 some of the contributors have changed jobs/companies – but their words of advice are just as valid...

How a Wildlife Film is Made

The idea of this chapter is to give you a brief overview of the whole process from idea to viewer. In conjunction with the next chapter – *The Variety of Jobs* – this should help you determine what part of the process you want to be involved in.

Bear in mind, however, that in some cases several of the jobs are performed by the same person. Indeed there are some film-makers who produce an entire film single-handedly – doing everything from camera-work to editing to music and narration, while others combine a smaller group of tasks such as camera operation and narration (eg Simon King).

Also remember that all of the tasks can be performed by employed or freelance people, and production companies vary in size from one employee to hundreds. It is a very variable industry!

Stage One – Conception

The most important, and often the hardest part of making a wildlife film can be coming up with a concept for the film in the first place! Many different factors will affect the choice of topic, style and development of the storyline, including the currently-favourite themes with the broadcasters. The initial concept may be the producer's own, or may have come from someone else who wants a part in the production, or a co-production deal. The creative side of originating ideas, and working them up into storylines that can be taken to pre-production, is the life-blood of the industry.

Stage Two – Pre-production

Basically this is the planning phase. Most importantly, in the first place, the film needs to be financed. It may be that the producer has taken the proposal to a distributor or broadcaster, and has signed a deal that includes the financial arrangements for the production. Or it may be self-financed with the hope of selling the finished film later.

In any case the producer will have an idea for a film which will be worked up into a shooting schedule with budgets. This planning can be very detailed for big productions and take some time to complete, with a number of people

working on different aspects of it. On the other hand, for the opportunist one-man-band, it may be simply a case of having a strong idea in the head and slinging the camcorder in the truck. BUT it is usually true to say – whatever the size and scope of the production – the better the planning, the better the result.

The producer will determine the team (if there is to be one) to work on the project. Depending on the size and complexity of the film there may be an assistant producer, more production assistants, researchers, director, camera and sound operators, script-writer, picture editor, narrator, composer and so on.

Stage Three – Production

This is the stage when the footage is shot and the location sound is recorded. At the very least this will involve a camera-operator in the field. They may record their own sound simultaneously, or be accompanied by a specialist sound recordist. In larger productions there may be more than one camera in action at one time and there may be a director to supervise this. Quite often the producer and/or assistants will accompany the film-crew to direct operations/ensure everything runs smoothly/help out/get in the way and annoy the camera-operator etc!

This stage may involve a period in the same place with the same team – often the case when the film focuses on a certain animal or habitat – filming wild dogs in Botswana for example, or it may involve juggling a large number of different camera crews scattered all over the world – such as when making a big series like BBC's *Life of Birds*.

Stage Four – Post-production

Once all the footage has been gathered, and the location sound recorded, we move into the post-production phase when the material is assembled into the finished programme.

The narration script will be written either by the producer or by a specialist script-writer, and the developed film, or video, will be edited. The producer (and/or director if there was one) often oversees the editing process. This is a very important stage and the picture editor's story-telling skills will help determine the strength of the final film.

The narration will be recorded and added along with any music. Ideally this will be music composed especially for the film, but may be library music for films with smaller budgets. Any final sound effects will also be added over the location sound by the dubbing mixer.

Lastly the titles and credits are created, then master copies of the film are made.

If it is to be shown on television the film will then be handed over to the broadcasting engineers for preparation for broadcast. Then it's over to the viewer, who hopefully will love it – and want more!

Formats

This is a convenient point briefly to discuss film formats available to the wildlife film-maker: not too specifically, as new formats/equipment are being developed all the time – but as a bit of background ...

The first major division is between photographic film and video. These days when we refer to wildlife 'films' we mean both, but not so long ago photographic film was the only origination option. Initially 35mm was the norm and it is still used for feature films and the occasional wildlife documentary. But 35mm cameras are big, heavy and expensive – and so is the film. 16mm cameras quickly became the wildlife camera operator's favourite, being lighter and cheaper but still producing great quality footage for TV. As far as film goes it still is the most frequently-used film format – albeit 'Super 16' these days.

Then video came on the scene – and from the 1980/90s was increasingly considered by wildlife film-makers. There are two main differences between film and video. First the quality: film has an unmistakable smooth, pleasing quality with excellent colour reproduction. Initially video struggled to compete with this, producing harsh, bright 'in-your-face' results. But video technology is improving in leaps and bounds and the results are getting closer to photographic film. Some may now find it difficult to distinguish between the two, and there are those who prefer the results from higher-quality video formats. There is definitely still a place for film though – and many of the top wildlife productions are originated on Super 16 film.

The other main difference is that photographic film needs to be chemically developed, whereas video can be viewed straight away. In the bush this may mean that the camera operator may not see the results of his/her efforts for some time – with the added fear that the film may be fogged/badly-exposed/scratched etc. Video users can instantly play back the footage to check content and quality.

Editing used to be very different too – picture editors classically cut actual photographic film into strips and joined it together into the desired sequences, while video editors transferred the film footage on to a master tape in a linear sequence. These days, in most cases, editing is done on computer – the footage having first been digitised on to the hard drive.

One important difference between film and video for the newcomer is the cost of equipment. 16mm film cameras are not cheap – even second-hand – whereas good quality can be obtained from a cheap DV (Digital Video)

camcorder – fine for initial practising. More about this in the chapter *How to get Started*.

Video was initially only an analogue format, which means that the images and sound are recorded as magnetic fluctuations on to a plastic tape coated with a metal-based compound that can store the fluctuations. The problem with this is that the quality of the recording on tape can degrade with time, and a reduction in quality also occurs when transferring the recording from one tape to another – during editing, duplication etc. Early formats were 8mm, Hi8, VHS, S-VHS etc. Then in the 1990s along came digital video technology. In the digital domain the images and sound are simply stored as a series of 0 or 1. Now the recording can be transferred, copied, stored on a hard drive, edited etc – all without loss in quality.

There is now a host of digital formats, and advances are being made all the time. At one end of the spectrum we have consumer DV camcorders – this 6mm digital format offers the best solution for extremely low cost acquisition, ideally suited to recording in difficult or confined situations, especially underwater. The equipment is small, light and cheap. Cameras can be either 'one chip' or 'three chip' (chips or CCDs (Charge-Coupled Devices) are used to store picture information – three CCD cameras splitting the colours into red, green and blue). One chip cameras are the cheapest but with a slightly lower picture quality. Three chip camcorders include the Canon XL1 – one of the top choices for DV wildlife film-makers on a low-budget. Cameras like this also have the benefit of interchangeable lenses, unlike consumer palmcorders.

The question is – 'is DV an acceptable format for broadcast?' Not an easy question to answer. To some extent it depends on the footage – if you have some cracking shots of a very rare creature for example then it may well be broadcast. It also depends on the intended destination for the footage – if it is for webstreaming or CD-ROM then DV will be fine, but if you were planning to shoot an entire feature for TV, broadcasters would certainly want it originated on a higher format.

Higher formats include DVCAM, DVC Pro, Beta SX, Beta SP, Digital Betacam (used in many documentaries – also known as 'Digibeta'), HD (High Definition – used in some feature films and bigger budget documentaries) and IMAX (the large film-format panoramic and 3D films). Digital Betacam is a viable alternative to Super 16mm film or telecined 35mm film, while High Definition Video can achieve a 35mm film-like picture quality at a reduced cost, and is rapidly becoming the standard sought by broadcasters.

The Variety of Jobs

The word *'variety'* is the key here. As mentioned in the previous chapter, the following jobs may each be performed by a different person (the usual case in a large production company), or one person may perform several of the jobs. You may be employed to do one or more jobs, or you may be self-employed and cover one or more of the categories!

You are unlikely to enter some of the jobs on an employed basis straight away. To be an employed producer for a company, for example, you are likely to have gone through other roles on the way – such as researcher to production assistant to assistant producer to producer. But of course there are many exceptions – if you have made a good name for yourself as a freelance producer you may be snapped up by a company on an employed basis. More information about how to set about getting some of these jobs is covered in the next chapter, *How to Get Started*.

The jobs covered in this chapter are those involved in the whole process of making a wildlife film. This includes a few essential associated jobs, such as location manager, stock footage library manager and distributor, and a look at some ancillary work such as multimedia wildlife production. The larger companies will have more senior management positions with a variety of titles such as Creative Director and Director of Operations, which we do not explore here as the roles vary from one company to the next. You would only move into positions like this after a successful career in production or management.

Case Studies

For each of the jobs we start with a brief description of the usual roles, and then look at one or more case studies. These are essential reading and really highlight the variety within individuals' careers. I have deliberately invited contributions from a wide variety of people currently working in the wildlife film industry – they are not all well-known names of people that started many years ago, since that would give you a one-sided and dated view of the industry. Some are very successful, some have struggled (some still struggle!) and some are relatively new to the industry. The aim is to provide you with as rounded a view of the industry as possible. They are not all from classic production companies either – positions here are very competitive and there is a variety of other employers and ways to earn a living making wildlife films that are often overlooked.

Each case study starts with the contributor's name, job description and company name (unless they are freelance). Then follows the names of three

films or series that the person has worked on that are either their favourites, or ones that they are most well known for (in some cases chosen from hundreds!). Then comes a description of what the person does, how they got started, and any tips they have for newcomers wanting to follow in their footsteps.

I urge you to read all the case studies, no matter which role you are interested in, as it will give you a better understanding of the processes involved, and how people move around within the industry.

In the *Contributors' Index* at the back of the book you will find further information about all the people who are case studies in this chapter (and those who have contributed to the chapter *The Future of the Industry*). You will also find their contact details, website links etc.

The Jobs:

Producer

The producer is really the overall boss of the film project – responsible for the production within a given budget, organisation, selection of other staff and day-to-day monitoring of progress. If the film is part of a series they may have a Series Producer above them, and there may also be an Executive Producer (who may for example also be the Distributor, or Managing Director of the production company, and want to keep an eye on things). But for most situations the buck stops at the producer.

The producer may well have come up with the idea for the film, may be working on a co-production with someone else who has come up with the idea (possibly the cinematographer), or may have obtained the rights to the property. The producer will be the one who has to determine where the money is coming from for the production – a distribution and/or broadcasting contract may have already been signed, or it may have external funding, or be funded by the producer/production company etc.

Some people want to get into production from the start – others want to move to it after, say, being a camera operator for someone else and then wanting to do it their own way!

During the pre-production phase a lot of the time will be spent on the telephone and computer, organising things, doing paperwork, and preparing for the production phase. Essentially this is an office job (except for maybe a few reconnaissance trips to the location(s)). During production the producer may well accompany the film crew and oversee/direct things on location, or, with a complicated multi-location production, may remain office-bound while production assistants go where the action is.

The producer may have written the narration script, or have worked with a specialist script-writer. At the moment it is common for the producer to write the script and then get it 'polished' by a script-writer – but better results are usually achieved when a specialist writer is used from the start! During post-production the other elements – music, narration etc – are drawn together and the producer often sits next to the picture editor to oversee this operation. The job doesn't end there, as even after initial broadcast time may be spent negotiating other rights, seeking further distribution/sales etc.

Qualities required: extremely good organisation; ability to do many things at once; a good understanding of finances and budgets; strong leadership skills; a good head for ploughing through complicated contracts, licenses and legal issues; ability to handle stress when it all goes wrong (crew illness, accidents, bad weather, leading animal being shot by a farmer, lack of the right sort of behaviour to film, deals falling through at the last moment, budgets going through the roof and so on).

Not much to ask really!

Case Study:
Mike Holding and Tania 'TJ" Jenkins – Producers
AfriScreen Films

Films: *A Wild Dog's Story* (BBC Natural World)

So you want to be a wildlife film producer. Why? Why would you want to get into a field of endeavour that requires monumental amounts of thankless work, sixteen-hour days, no weekends, rare holidays, endless haggling with boneheaded customs officials in seedy third-world border posts, inordinate amounts of trivial paperwork, bombardments of mosquitoes, hundreds of consecutive four o'clock wake-up calls, cold, heat, dust, rain, flies, snakes, mud, broken equipment, nights spent wedged in thorn trees surrounded by lions, waiting on deserted bush airstrips for rickety planes that don't arrive? There seems to be no comfortable answer, and yet if you ask us to swap what we do for anything else, the retort would be a resounding "No!"

We, that is Tania "TJ" Jenkins and myself, formed AfriScreen Films in 1996, with the specific intention of trying to break into the heady world of 'blue-chip natural history' – an ambitious dream indeed. In retrospect, we were lucky, before seriously getting into the wildlife game, we both had a dozen years under our belts in other challenging areas of the film industry.

My filming career began in a manner reminiscent of a Graham Greene novel. Drowning my sorrows one evening over a cold beer at the infamous Norfolk Hotel bar in Nairobi, I chanced into conversation with a 'famous' BBC Television News reporter, who was looking somewhat shell-shocked. Ten

minutes later I had a new job – off-road driver of an antique, bullet-ridden Land Cruiser, instant camera assistant, apprentice sound recordist, Swahili translator – for a mission into the war zones of Uganda, leaving the next morning! Looking back, perhaps my only qualification for such an abrupt entry into this insane escapade (we filmed the war and dodged bullets sporadically for weeks at a time) was an insatiable appetite to learn, patient resilience in the face of adversity, a tolerance for extreme discomfort, thirst for adventure, and an intimate knowledge of Africa. Twelve months later, unwilling to go on witnessing more misery and death than I care to recall, I resigned.

You'd better have nerves of steel

Several years later, after trying my hand with moderate success at aerial photography, marine research, magazine editing and writing, I rejoined the film world, this time producing corporate films. Once again my qualifications for the job were somewhat threadbare, but enthusiasm and persistence paid off, and within a year I was writing, producing, filming, editing and sound-mixing corporate films for the likes of Coca Cola, BMW, and other blue-chip companies. I gave myself ten years really to hone my skills in the corporate film world, and I wouldn't swap those years for anything. They not only allowed me to practise every detail of the craft of film-making, but equally important, taught me invaluable lessons about selling ideas, budgeting, storyboarding, scheduling and the intricacies of post-production.

TJ's background is equally diverse, yet certainly more spectacular. From a first job as a humble production runner on a television drama, she rose with meteoric rapidity through the ranks of 'production' in feature films and

television to become, by the tender age of 26, Line Producer on one of the biggest feature films ever to come out of Africa. Commanding crews of 250 people and 5,000 extras through re-enactments of the Soweto riots, in Soweto and during the actual crisis, gives some idea of the kind of forward planning and almost military precision that she brought to the job. Yet these skills were learned somewhat in the same manner as mine. Staggering hours of work, humility in the face of tyrannical bosses, almost inconceivable attention to detail, uncomplaining assumption of heavy responsibility, near-clairvoyant forward planning and preparation, checking and double-checking and triple-checking every aspect of every production every minute of the day.

Diversity and adaptability were the keys – sharing laughs and coffee with the likes of Whoopie Goldberg, Holly Hunter, Brandon Lee, Ernest Borgnine and Oliver Reed one moment, and dealing with the wounds of a crew member violently stabbed over lunch the next. Throughout these experiences, she learned the art of fastidious planning, anticipation, meticulous budgeting, storyboarding, schedules, bookings, location-finding, money-management, people-management and cool-headed crisis-management.

The point of this long potted history is simple: wildlife film-making is changing fast, and the name of the new game is 'multi-tasking'. My function in our partnership is primarily as cameraman and creative director, but I understand and can undertake all the multiple facets of the business. TJ functions as a producer in the feature-film sense of the word. She skilfully handles budgets, logistics, politics, crew, scheduling, distribution, legal matters and finances. Together, we cover every aspect of film-making, with a wealth of diverse experience behind us.

The fickle demands of commissioners and broadcasters become more complex daily, and the successful producer will not only have an intimate understanding of wildlife, ecology, animal behaviour, conservation, wildlife ethics, indigenous people issues and plain old 'film-craft', but will need to be comfortable with the rules of drama and feature films, factual programming, historical dramatisation and all the other genres of film. Beyond all that, the wildlife film producer needs the same skills as a 'Producer', 'Line Producer' and 'Director' in the Hollywood sense of the word. Wildlife film-making is a complex business, no less so than any other form of film-making. In fact, the demands are often greater – usually one or two people have to fulfil roles that would be met by dozens of individuals in other film genres.

From a pure 'Producers' perspective, TJ will be the first to assert that making wildlife films is harder than all her time spent producing feature films and TV drama. Where once she had a team of production managers and assistants, she now handles an equal number of production and logistical complexities by herself. Where big city production could be handled with call sheets, cell phones, and production runners, now she has to deal with a crew in the middle of the African bush, hours from the nearest hospital, the only communications once a day on a crackly short-wave radio. Where once she could intricately plan, minute by minute, the lives of actors, directors, cameramen, grips and dozens of crew members, now she has to

foresee and anticipate the vagaries of wild animal behaviour, the inconsistencies of weather, interminable broken-down vehicles, and deal with the worry of remote cameramen being bitten by cobras too far from a hospital to save their lives. Bottom line is that if you want to get into this business, you had better have nerves of steel!

So, our ground-level advice would be this: gain as much experience as you can, in as many aspects of the film business as possible, in the shortest possible time. Never, ever, pass up an opportunity to learn, to gain new experience – however menial the task may seem (we've done our time sweeping stage-set floors, making midnight coffee for cantankerous crews, washing cars, fetching pizza, you name it!). Don't ever believe that wildlife film-making will be glamorous – it's not. Don't wait for lucky breaks – create them! If in doubt – just do it! Do anything legal to get yourself into a position where you can gather new skills. Work harder than everyone else – simple maths says that if you are prepared to work sixteen hours a day, you will learn twice as much as those who settle back after an eight-hour shift. Diligence, patience, attention to detail, respect for experienced people, unquenchable enthusiasm, good humour, good manners and a passion for film are essential too. Learn skills outside the ambit of wildlife film-making – the gap between wildlife documentary and feature film narrows every day. Study fine art and literature and mythology and poetry and great movies – they will enrich your films. And perhaps most important – learn to love stories, story-telling, and story-tellers. It's what you want to be.

Case Study:
Peter Crabb – Independent Producer
Blueplanet Productions

Films: *Shark Gordon* (Animal Planet Shark Series)
An Octopus's Garden (Discovery Channel)

When I was a lot younger, television was new and scuba diving was dangerous. Jacques Cousteau and his intrepid divers were my absolute heroes. As I watched Cousteau, Falco and the divers gliding through mesmerising underwater seascapes getting close-up to sleeping sharks and marine iguanas, it struck a chord.

I studied many things at University, and, while tempted by the new and exciting world, I remained steadfast in my mission to be a marine biologist. I graduated with a Master's degree after

writing a book about the sex life of a fish. This was followed by an opportunity to join the university staff as a project manager working in the New Zealand Fjords. I lead a team of students engaged in underwater biological surveys, monitoring-work and quantitative video analysis.

On one of my last fjord trips, I met a wildlife film crew doing reconnaissance for a film about bottlenose dolphins. I sold my skills and talents, and some time late, the opportunity presented itself to join this team as dive guide and boat-driver. After some on-the-job training, I was operating tow camera, bow camera and pole. On occasions we entered their realm to get footage and later we used an ROV and night-diving to capture new and unusual material. I returned part-time to University to study film.

I was now on board at Natural History New Zealand Ltd and the next project was a rare opportunity to dive with some of the largest whales in their winter breeding grounds. In the middle of winter a small crew sailed to the New Zealand Sub-Antarctic for two months to film southern right whales. Next I worked on a film following a New Zealand pod of orcas. Later I researched, developed and pitched a film to Discovery Channel called *An Octopus's Garden*. This then lead to my role as Assistant Producer in the field for a 13 x 30 min series about sharks shot on location in five countries depicting 13 species of shark. I have since worked with National Geographic on stories about global climate change in Tuvalu, and the BBC on crayfish, octopus, sharks and giant squid.

For the most part, underwater filming equipment is essentially the same as that used for topside filming. Some people even use tripods and time-lapse underwater. The cameras are in a watertight casing called a 'housing' and need special ports to correct for the distortion of objects that occurs underwater. Nowadays most underwater footage is shot on video because video operates better in low light situations and videotape lasts longer than film – extending dive times. For cinema, film is necessary for projection and housed cameras are available in super 16, 35 mm 70 mm or IMAX formats.

Dive time is a limiting factor for underwater film-makers and I think it is important to be able to film subjects in the shallowest water possible, allowing for the best light and dive times. Dry suits are essential in temperate, sub-Antarctic and Antarctic conditions; protection from jellyfish and sunburn are higher priorities in the tropics. I find more weights than necessary a key to staying stable and in control while shooting. Using lights underwater compensates for the wash-out of hues and colours that occurs with depth. A buddy under great buoyancy control holding lights makes all the difference.

Staying abreast of advances in technology can play a big part in underwater film-making, and knowing what the technology can do for you at the planning/research stage can open up new approaches and story angles. For example the recent advances in rebreathers, remote cameras and mixed-gas diving have contributed to my work. Rebreathers do not produce bubbles or noise and can help to get divers close to fish, and are essential in silty

environments like caves or shipwrecks. Remote cameras can penetrate to depths not accessible to divers, while mixed-gas can lengthen bottom times and increase safety.

Being a biologist provides me with a greater insight into behaviour, the seasonality and life history of ecosystems, and when researching scientific concepts. Knowledge of film-making craft is valuable for understanding the construction of storylines, creating drama, revelation and character development. The use of editing, sound and music to create pace and flow is a hugely important technique in the language of film. However, film-making is a team endeavour, and perhaps most important is allowing those people versed in their craft areas to contribute to your film, as their experience will show. People skilled in project management and finance are essential for keeping your film within deadlines and under budget.

Wildlife film-making is about telling stories and the really great stories are based on great ideas and thorough research. Research will involve many hours on the phone, personal networking, chasing contacts, and using the Internet or the nearest university library. A natural history video library is ideal for studying those wildlife films already produced.

While it seems like much effort and suffering, the rewards are worthwhile and perseverance pays off. It is a special feeling to capture the behaviour, or a glimpse of an animal that you have been chasing for weeks – and the footage is clear, sharp and correctly exposed. While wildlife film-making falls into the category of 'factual', you should not let the facts stand in the way of a great story.

Case Study:
Martin Atkin – Features Producer
Greenpeace International Video Production Unit

Films: *Grains of Truth*
Feeling the Heat
Taking back the Earth

I've been working for Greenpeace International since September 2000, based at the Video Production Unit in Amsterdam. I produce video for all the Greenpeace campaigns but concentrate mainly on Genetic Engineering, Oceans and Climate. I shoot, script and produce a wide range of video material including documentaries, VNRs (Video News Releases), promos, commercials and news reports. I also commission cameramen, arrange satellite feeds, and spend a lot of time on the phone persuading

agencies and broadcasters to take Greenpeace footage!

I'm first and foremost a journalist – I spent twenty years in the UK newspaper, radio and television industry before coming to Greenpeace. I guess I followed the "old fashioned" route – I didn't go to university but started as a junior reporter for a news agency and took it from there. After stints as a radio reporter and presenter, I took a job as assistant producer with the BBC in Leeds and it was there that my love-affair with video began. Film as a news-gathering medium was being phased out and the first PSC crews started to appear. It's heresy to a lot of wildlife film-makers but I've always liked video for its versatility and cost-effectiveness.

I've worked as a director with BBC TV News, ITN and Meridian and freelanced as a producer/director, working on everything from corporates to sport. I recognised that the de-regulation of the British television market in the eighties and early nineties would change the way we all work, and set out to equip myself with as many skills as possible. I learnt to vision-mix, edit, and began to shoot much of my own material, operating as a one-man band producer/cameraman. I realised that environmental and conservation issues were not getting the attention they deserved on the daily news agenda, and set about trying to show that it was possible to produce low-budget, high-quality features for news and current affairs. I'm a huge admirer of blue-chip, high-end wildlife film-making, but I wanted to prove it was possible to make cost-conscious environmental programmes which would still have an impact.

So I jumped at the chance to join Greenpeace International. Famous for its action footage and with a 30-year history of making hard-hitting television pictures, Greenpeace offers me the chance to work the way I like best – independent, taking risks, travelling light. But that doesn't mean cutting corners. In an increasingly competitive market, it's vital we maintain the high quality of our output. All the Greenpeace ships carry Beta SP and DV kits, and are equipped with edit suites and satellite uplinks. These days I usually shoot on mini-DV – my current favourite is the Canon XL1. This is partly to keep weight down and partly because it's cheaper to replace the cameras when they get confiscated by police or dropped over the side of an inflatable during an action! Even for longer shoots I travel with the minimum of equipment and use natural light-sources wherever possible. I have even been known to get the entire camera kit on the back of a bicycle!

I came into the industry at a time when rigid divisions of labour were becoming more blurred. I've been fortunate to be able to try my hand at different skills and choose a job that combines them all. But even in these days of multi-skilling it is essential to have one core skill around which you build the others – in my case, that's telling the story through good script-writing and good journalism. I'd advise anyone considering a career in video to acquire as much practical and technical knowledge as possible. Theory will get you only so far. Try and find an employer who will offer formal training combined with on-the-job experience. And don't expect to get rich! After twenty-odd years of working in the television industry, coming to

Greenpeace was a refreshing change. Budgets and resources are extremely limited and there's a constant battle to get our pictures on-air. But it's also the realisation of a long-held ambition – using my skills and experience to achieve positive change. I believe passionately in the role of video as a cost-effective, dramatic medium for environmental programme-making.

Case Study:
Mike H Pandey – Director Cameraman and Executive Producer Riverbanks

Films: *The last Migration*
Shores of Silence

India – not only the custodian of some of the most exquisite and diverse wildlife – it has some of the most challenging and demanding terrain to offer – especially to the wildlife film-maker.

My 25 years as a wildlife film-maker has been an exciting experience – both high and low – an adventure and a great learning process that continues even today.

The passion for wildlife started early; our childhood in Kenya left a deep impression and an abiding respect for wildlife and nature on me and my brother. It was my brother, Ishwar (IC), armed with a box Brownie (and with me in tow) who triggered off the spark in me that in later years ignited into a full-time profession.

Filming in the wild is different – apart from the basic training as a cameraman which is without doubt the foundation of all hardcore wildlife film-makers, the 'feel for the wilds' and knowledge of and respect for the bush are vital. Not only to get great sequences but also to stay alive – especially in hostile terrain. Additional qualities that go a long way, especially in India, are: the patience of a vulture, the stubbornness of a mule (especially while filming the great cats, tigers and lions who spend most of their life sleeping or yawning) and the eyes of an eagle.

I remember staking out in a hide near a waterhole in India from 3 in the morning until 6 in the evenings for sixty days – with the temperature pushing 49 degrees C – fighting sleep and exhaustion waiting for the tiger. It finally appeared – a flash that lasted thirty seconds – and it was gone. The footage however was spectacular and I count it among the best I have done even today – but what made it possible was that I was awake and alert and with ears and eyes open for every sound – even after 61 days. I was using an Arri SR with a wet towel wrapped around the film-mag to keep the film from cooking, but the focus kept changing owing to thermal expansion of the lens barrel. Portable collimators are a life saver – the nights in the jungles in India have sudden drops in temperature. In a location like India backup support is almost impossible – units have to be self-sufficient and self-reliant.

As a wildlife film-maker, establishing a base in India has been difficult. India has very little wildlife film history and very few supporters. Considering the size of the land it is almost non-existent. When we first arrived here we had to make a place for ourselves. I had to put down roots, make friends, observe, understand difficult professional dynamics, create a base for myself in a community hostile to foreign-trained youngsters. I had knowledge, but no equipment and no resources. No suitable equipment, especially for wildlife documentaries, could be bought or rented. Despite all these odds I chose the documentary film genre, dug in my heels and worked towards my first Arriflex 16 ST.

Television was in its infancy: with no sponsors or interest from the business houses it was an uphill climb. The idea of making films about animals and conservation gave birth to strange expressions on many a face that I encountered during my struggling days! Some locally-funded documentaries finally set us off – these were on 35 mm and were to be donated to the films division – the then premier government agency for documentaries.

My documentaries took me all over the country, and I could observe the depletion and slow erosion of natural resources all around me. The land was being aggressively exploited for the bottomless need of the ever-growing population. Cities were mushrooming, forests were being cut, poaching was rampant, pollution was on the rise, man/animal conflict had begun in some areas.

In spite of this we kept on filming and gathering footage on different issues and subjects wherever we travelled. A film on tigers for World About Us

cropped up just as Project Tiger was announced. It opened many doors and conservation and wildlife began to gather some momentum. Three films for Heinz Seilmann followed – I was the cameraman and location manager. Film production units from all over the world were now concentrating on India – the boom had begun.

Natural History films were being made by the giants: BBC, Discovery, Nat Geo, ABC – the competition was growing. No way could we match them for equipment and resources, and finally the end product. It was around this time that I thought of another angle – not pure natural history but one where conservation was not viewed in isolation – where it related to man.

Man and animal were both dying in some parts of India – an awareness film had to be made. The hard fact was that there was no sponsor for my ideas. In spite of this, with whatever funds I could muster, I set off to make the man/animal conflict story: *The last Migration* – a film on the elephant herd capture in Sarguja (Central India). Support from a few friends, a dedicated team, my last drop of ingenuity, and resources went in to complete the low-budget shot on standard equipment film. The story content was powerful and I had the courage to send it to the world's finest platform, Wildscreen, in 1994. It was a litmus test for me, and ... it won the Wildscreen Panda! The first Asian film to ever win a Panda Award.

This was very encouraging for my team and for many aspiring young film-makers as well – but the situation with the sponsors remained unchanged. Despite the accolades, the multiple prizes and the publicity, both at home and abroad, there was no funding for our next two projects – especially a film on the whale sharks – *Shores of Silence.*

The film took three years to make because of the difficult situation and also because of lack of finance. No record in the world showed India as a whale shark destination. No-one was prepared to support a film on a species they believed to be a figment of imagination. The film was not funded by any agency or government, but as film-makers we felt we could not turn our backs on an issue that needed to be brought out into the open. We put in our own funds and managed to produce the film.

Fortunately – once again – our film got the best platform in the world; at the Wildscreen Film Festival in 2000, *Shores of Silence* won a prestigious Panda Award! It got talked about – the fact that it also got nominated in the conservation Animal Planet category showed that people had understood the urgency of the matter. It was also a documentary that was the first to discover the presence of the whale sharks in India – and a film that made a difference. Within a few months of our showing it to media people and policy makers – the Government of India declared the whale shark a protected species, bringing it under the Wildlife Act of 1972: this is a law under which the killing of whale sharks is banned and draws seven years' imprisonment. The film has been the catalyst in bringing about this legislation, giving the whale sharks a new lease of life.

For a country that had no wildlfe film history it is heartening to see that these two films have made an impact internationally and opened the gates to bring India into the mainstream of wildlife films.

Wildlife film-making techniques and prowess grow along with your own instincts – aided by experiences, perceptions and humility. Knowledge, experience, commitment, dedication and sensitivity all go towards making some of the finest craftsmen in the trade. But then again it is one of the most adventurous grand holidays – and you get paid for it.

Assistant Producer

On a big film project, or a series, there is quite often an assistant producer to whom the overall producer can delegate any amount of his/her duties. The assistant producer will take some of the responsibility for ensuring the production is finished on time and under-budget – a similar role in some companies is titled Production Manager. The assistant producer may find themselves involved in any of the work described earlier for producers – basically they do whatever the producer chooses to delegate to them. This may involve accompanying the film-crew on location.

This is an excellent stepping stone to becoming a producer because you get to do a producer's work, with some guidance, and yet don't take on all the responsibility!

Qualities required: essentially the same as the producer's but with the added ability calmly to do anything you are told to do; good general knowledge of natural history and how the film industry works.

Case Study:
Emma Ross – Assistant Producer
Freelance

Films: *O'Shea's Big Adventure* – Siamese Crocodile (Channel 4, Animal Planet)
The Real Macaw (Channel 4)
Jurassic Shark (Channel 5, Discovery)

The job of Assistant Producer varies from film to film and company to company. Sometimes your role is little more than a glorified researcher while in other situations an Assistant Producer will be expected to direct sequences, record sound and shoot DV material. But in broad terms the Assistant Producer works closely with the producer to find stories, characters and locations, secure access and set up the shoot. You are usually the one who is closest to the logistics – figuring out when, where, for

how long, for how much and then making it all happen, smoothly. It's a varied and exciting job that's as much about working well with people as about being a thorough researcher, creative story-teller and fixer.

So how does one become an AP? Everyone's story is different but I suppose it was really on graduating (with a biology degree) that I seriously set my sights on a career in wildlife film-making. Certain this was where I wanted to be but uncertain how to get there, I signed up with a conservation film festival in London and spent a summer viewing and helping kids make their own conservation films.

It was good experience but I was still no closer to making my own films, and so, working in a pub at night, I spent the days writing to every Executive Producer in the book (the PACT directory and Wildscreen directory are good places to start) requesting their advice on how to enter the industry. I'm still incredibly grateful to all those who invited me in to their offices and eventually gave me work experience, which led to development work, and within six months I had a researcher's position at Survival Anglia. I spent over four years at Survival before leaving to work freelance last year (2001).

Working freelance you're facing the same problems as a newcomer to the industry – whom should I be talking to, how do I get myself noticed and how do I get people to employ me?

I've only ever seen two wildlife TV jobs advertised in a paper or on a web site. Wildlife production companies receive so many unsolicited CVs they don't need to advertise. So to be in the running you generally need to let people know you're out there and give them reasons to be interested in you. It's hard work and time-consuming, but when working freelance finding the job is very much part of the job.

Here are some thoughts on how to get there...

Get talking to people – whether it's at a film festival (you might get work as a volunteer) or in an Executive Producer's office – your CV says very little about who you are, what you can offer and what you'd be like to work with. Even if a production company has nothing to offer you now, they will be able to give advice and may well have opportunities for you in the future.

Get some experience – some production companies take people on for work experience. It's unpaid, and remarkably hard to get, but in my experience very worthwhile.

Alternatively you might consider going to film school or taking a short course. Really anything from writing articles to making your own short films are good ways to both get experience and show what you're capable of and whether you like it.

Develop your own ideas – not all production companies are interested in outside ideas but if your story is unique and you have the access then few will turn it away. You are still a long way from getting your idea commissioned but you will have made a contact and hopefully a favourable impression. Also bear in mind where your idea would be placed, which channel and which slot you would pitch it to.

Watch a lot of television – it's amazing how many people don't. As a newcomer to the industry you have a unique and new view of its product; make that an attribute, have an opinion.

And finally, decide if it's really for you. Although the ups are fantastic and the job has allowed me to meet some fascinating people and work in some amazing locations, there is a down-side; the industry is very competitive and offers little job-security. Being passionate about wildlife isn't always enough; you have to be talented, good at working in a team and have the determination to be continually making opportunities for yourself.

I'm still working at it.

Case Study:
Jessica Wootton – Assistant Producer
Freelance

Films: *Amazing Animals* (Partridge Films for Dorling Kindersley Vision)
Toyota World of Wildlife (Granada Wild / Sunset & Vine for Toyota)
Deadly Dragons with Steve Irwin (Partridge Films for ITV)

I was born and brought up in Kenya and was lucky enough to have parents who loved to get out of Nairobi and into the bush at almost every opportunity. Even our suburban garden was full of wildlife. Tree frogs used to lull me to sleep at night and bushbabies and genets would wake me up again with a shriek! Monkeys used to come and admire their reflection in my parents' bathroom mirror, leaving sticky fingerprints on the glass. A flock of noisy hornbills used to arrive as if by magic when the avocados fruited, and they feasted until there were no fruit left. Chameleons lived in the creeper over our veranda and I can remember great excitement on one occasion when a five-foot spitting cobra joined us for lunch in the dining room! When you've been surrounded by wonderful creatures like these all your life it's pretty much impossible not to be passionate about them.

My love of wildlife led naturally to a degree in zoology, which I did at Bristol

University. During my degree, however, hours spent standing about in the cold, recording data and doing what seemed like endless statistical calculations taught me that I did not have patience to make a real zoologist. So, after three years, there I was, armed with a degree in zoology, but little the wiser about what kind of a career I should pursue.

Then it dawned on me – I've always been a bit of a wildlife evangelist and I realised that the very best way to stay involved with the wildlife I loved so much (without being bored to death by number-crunching), and to get other people enthused about it at the same time, was to go into wildlife television. Yet I knew absolutely nothing about the business, and, realising that a degree in zoology didn't really qualify me for a career in telly, I embarked on a Masters' degree in Science Communication (a media degree for science graduates) at Imperial College London. It was the best thing I could have done because it gave me the training, focus and confidence I needed to embark on my chosen career. Like all science graduates, my degree had taught me to write like a scientist, drilling out of me any vestige of creative writing talent. The Science Communication MSc taught me to write, taught me the basics of TV and radio production and got me thinking creatively again. An incredibly valuable part of the course was work-experience placements at the BBC Natural History Unit and the BBC World Service Science Unit.

A year later, with the Masters' under my belt, I was by now much better equipped to enter the world of wildlife television. Nonetheless, it took me some time to get my first job in the business. It was short contract as a junior researcher at Partridge Films in Bristol – and I loved it! Over the following year or so I had several more short contracts (as well as the inevitable periods out of work!) in various production companies in Bristol and London. Finally I ended up back in Bristol working for Partridge Films again (latterly Granada Wild), where I was made a member of staff, settled in and stayed five and a half years. Now I've moved up to London and I'm doing the rounds, talking to various production companies, networking and looking for work up here. Back in the world of freelancing, I never know where my next job is coming from, but I hope it'll be a good one!

My advice to anyone looking to get into wildlife television would be to be sure that you are really determined that this is what you want to do. There is an awful lot of competition for jobs all the way up the scale and sometimes it can seem like finding your next contract doesn't get any easier. Also – pay tends to be pretty poor compared to almost any other career you could choose, so if it's job security and good money you're after, go get a "proper" job and use your holidays to get your wildlife fix! On the other hand, if it is really what you want to do, go for it, network like mad and be persistent. Getting the best jobs is as much to do with luck and whom you know as it is

to do with talent and experience. But the rewards of the job are, of course, wonderful – and you also get to work with a generally lovely, laid-back bunch of people who are as potty about wildlife as you are.

Researcher

The work of a researcher can be very varied. Some will spend part of their time acting as production assistants – performing any tasks needed to ensure the details of the production are ironed out. Others will be involved earlier on in the pre-production phase – helping the producer plan and write the production. This may involve researching into similar films previously produced, searching the Internet for information, reading around the subject, finding out more about locations, verifying the accuracy of scientific data, tracking down experts in the subject of the film etc.

The researcher plays an important role in natural history films by finding out as much as possible about the creatures to be filmed. They will then be an important advisor to the shooting script-writer and the producer as the film progresses. Some in-depth programmes may require a specialist researcher – a marine zoology expert for example.

There are people who stay being a researcher for the love of the process of seeking natural history knowledge, while others start out as a researcher on their route to other production roles.

A tip from Canadian Broadcasting Corporation's Producer Caroline Underwood is to get qualifications in biology/zoology and film. When she needs researchers she finds plenty with biology degrees but few who also understand what is needed from a film production/industry point of view.

Qualities required: an enquiring mind; an excellent general knowledge of natural history – biology/zoology degrees and postgraduate qualifications often preferred by employers; a good knowledge of the processes for finding out information – especially using the Internet and libraries.

Case Study:
Hazel Cripps – Researcher / Co-ordinator
Imago Productions

Films: *Bears Behind Bars* (a Genesis Award-winning documentary highlighting the plight of bears in Japanese bear parks)
Adopt a Wild Animal (an international 'red nose day' event for endangered wildlife)
Wild at Heart (a family-orientated series focusing on endangered animals)

If you're reading this then I guess, like me, you're passionate about all things animal, and hoping for a career in wildlife film-making/TV? But what does the job involve and how do you get your foot in the door? Here's a brief introduction – I hope it's of help!

My role as a researcher/co-ordinator on documentaries and popular animal programmes demands a flexible and diverse range of skills and involves a combination of specialised, practical and administrative jobs: from in-depth subject research to telephone interviews; location-scouting to assisting the film crew; scripting to writing programme support documents; production scheduling to arranging travel logistics; health and safety monitoring to handling technical equipment; the list is truly endless ...

I entered the world of TV with a creative background: a degree in the Arts followed by several years working freelance as a researcher/copywriter, while gaining as much relevant work-experience and training as possible to make myself invaluable in an increasingly multi-skilled TV environment. This experience has prepared me well and means I can rise to any challenge that comes my way. I'm also lucky enough to be able to continue training on the job: I've recently begun an in-house NVQ Level 3 in Production Management and am also initiating training in presenting, editing and camera work among other things.

If you want to become a researcher, your CV should reflect some key practical skills including: knowledge of and experience using modern/archive research methods; good oral and written communication skills; you should be *au fait* with IT; have good organisational abilities and be a team-worker with creative flair. Awareness of current TV/wildlife film trends and knowledge of Health and Safety issues specific to the industry would also be advantageous. Your personal attributes are equally important, with confidence and good social skills a must, as are adaptability, resilience

and bundles of enthusiasm. And you just can't have a big enough book of reliable contacts and references to help give you the edge.

The best advice I can give any newcomer to this industry is to get as much and as varied TV work-experience as possible – that way you'll get a good idea of the ins and outs of the production process, discover which aspects you enjoy the most and (hopefully) find out if this really is the career for you. Unless you are already multi-skilled with a relevant work-history or specialist qualifications, the most common first TV job is as a runner or production assistant – often jobs that can be found by making yourself invaluable while doing work-experience! Once you've got your foot through that all-important production company door, the possibilities are endless.

Finally, don't be fooled into thinking a job in TV means glamour and lots of money – the majority of roles are extremely hard work and anything but glamorous, often time-pressured with multiple daily deadlines and long unsociable hours. There is fierce competition for jobs/promotion, and with money for most production staff in the industry being less than desirable, it's a wonder that any newcomer wants to let themselves in for it! But the rewards make it all worthwhile: getting out and about filming, studying some amazing animals, meeting new and interesting people, watching your team effort finally make it to screen and seeing your name roll past on the credits ... it's a great buzz after months of hair-pulling and nail-biting – but well worth giving a go if you're up for it, so good luck!

Case Study:
James Chapman – Researcher/Assistant Producer
Imago Productions

Films: *Adopt a Wild Animal 2002* (Animal Planet/Discovery Worldwide)
Legends of the Gobi (National Geographic)
Gladys the African Vet (Discovery US/Survival Anglia)

Getting your foot in the door

I know it's a cliché but it's all about being in the right place at the right time. However, there are certain things you can do to get yourself noticed and put yourself in the right place. This might mean a lot of emailing, letter writing or hassling ... but your persistence could be worth it in the end – it was for me! Make sure, however, that you strike the balance between being persistent and too pushy – you don't want to scare potential employers off.

I managed to get my foot in the door by doing some unpaid work-experience for an independent production company that specialises in animal/people documentaries. Fortunately the job paid off since it led to my first job as a junior researcher working on a programme about the chief wildlife vet in Uganda.

Since then I have moved to a larger production company based in Norwich and have been lucky enough to work with some of the top professionals in the industry while being involved with some award-winning films. Working at an 'indie' (independent production company) has meant more exposure to a wider number of projects than I think I would have got at a larger company like the BBC. I think that has helped accelerate my training.

Here are a few tips:

• One of the key things that I would recommend is to try and be multi-skilled as much as possible. It is important to have a number of skills under your belt and not to be too specialist; that way you become a real asset to all areas of production.

• Try and make opportunities for yourself, by offering ideas for new wildlife films or strands for example. The more creative and confident you can be, the better.

• Don't be fooled into thinking you need a degree in media studies in order to get a job in media, because you don't. For me I think it did help having a degree but it is not always essential. I did my degree in Ecology which seemed to blend quite well with becoming a wildlife television researcher.

• Don't forget there is also a range of courses such as City & Guilds, BTEC, NVQ etc. IT skills are increasingly essential. Above all it is important to choose a subject that you are good at and enjoy.

The highlight of the job so far was developing a story about tiger conservation, setting up the shoot and then directing my first short film. It was filmed on location in the Khao Yai National Park in Thailand. The film featured the local anti-poaching patrol and shortly after it was broadcast worldwide (including Thailand) I heard from one of the park officials to say that the film had boosted the anti-poaching patrol's morale and given the team some well-deserved recognition. That sort of thing makes the job really worthwhile.

This year I have been working on a one-hour film about lions in one of the last true remaining wildernesses in the world – The Okavango Delta in Botswana. I always wanted to go to Africa so hopefully later this year, if my camera assisting skills are up to scratch, I will be filming lions from a hide in the African bush! It just shows that long after you've got your foot in the door the pressure never stops to push yourself to the next level and get where you want to be.

Production Assistant

Depending on the size of the production there may be one or a number of production assistants. They are not producers' deputies (that's the Assistant Producer, although terminology does vary from one company to the next) but form part of the production team, undertaking any tasks required of them by the producer.

Some of their work will cross over with the researcher and they may find themselves typing shooting-scripts, checking costs, liaising with film-crews, booking travel arrangements etc. A good position for learning more about the industry.

Qualities required: good organisational skills; ability to handle figures and concentrate on every little detail; confidence to deal with all manner of people; some general knowledge of natural history.

Administration and Publicity Co-ordinator

As with most companies there will always be a need for extra administrative staff and people to handle marketing/publicity etc. If you have the right skills this can be another way in – if you impress with your work and ideas you may be able to move over to production jobs further down the line. Having said that, there are publicity specialists who wouldn't swap their role for anything!

Qualities required: good organisational and communication skills; secretarial skills; confidence to deal with people; enthusiasm to market ideas and products; knowledge of different media and command of tone in writing releases.

Case Study:
Jordan McRickus – Administration and Publicity Co-ordinator
Imago Productions

Films: *Legends of the Gobi* (National Geographic)
Bears Behind Bars (Animal Planet Europe)
Wild at Heart (Animal Planet Europe/Anglia TV)

After leaving school I completed a two year BTEC National Diploma course at Norwich City College. As part of that course I had to complete several weeks' work-experience which I carried out at many places including Anglia Television where I worked as an audience researcher/runner on *The Vanessa Show*. This gave me an insight into studio production and also gave me a huge amount of confidence, as well as plenty of contacts – that's where I

first heard of Imago. As soon as my course had finished I applied for work-experience at Imago which I got, and after six weeks of running on several productions and making over a thousand cups of tea I ended up as the MD's PA. This was an excellent opportunity to learn more about the business side of wildlife film-making – getting to know the broadcasters and what they're looking for.

For the first two years at Imago I worked as a runner, researcher and production co-ordinator on many different programmes from Whipsnade to Abu Dhabi, Borneo to Japan – just because you're not out there on the front line doesn't mean you don't feel the pace or the sense of teamwork that goes into making it all work. I consider myself extremely lucky to have had this wide range of experience through many aspects of production, and now as Publicity Co-ordinator I'm even more involved with each production.

I'm responsible for getting the publicity pictures wherever they're filming by liaising with producers and researchers on the shoots, publicising each transmission by producing tx cards, round-robin-emails and of course getting those news stories. This involves endless chasing of reporters and editors, which can be frustrating as sometimes it can take an entire week to end up with only a few lines in the local paper! I also submit programmes for various festivals and awards – we've recently won the international Brigitte Bardot Genesis award for our *Bears Behind Bars* film and a Merit Award for Excellent Cinematography for *Legends of the Gobi* at the 2002 International Wildlife Film Festival.

I have now been working with Imago for nearly four years, and throughout my career here I have always had the opportunity to move into any role within production, whether a researcher or production co-ordinator, but I chose to stay in the heart of the company as it has given me the opportunity to see so much more. I think you learn a lot more by working in a smaller company rather than a big corporation – so if you can get in with a young vibrant company, I would jump at the chance – then you can grow with the company. It will be extremely satisfying to see how far you've both come along.

My case study shows that you don't necessarily need a degree to get into television – it is a bit of 'the right place at the right time' – but as long as you have the commitment, enthusiasm and determination you'll get where you want to be. It's not just about the love of wildlife or the love of making television – you have to feel for the people you're working with as well as the

company to make a successful team. Even if you don't have the knowledge, the willingness to learn is just as important.

Director

In feature film-making the director's role is to interpret the shooting script and direct the actors and cameras accordingly. Not all wildlife films require a separate director – the wildlife camera operator filming on location may well be alone and have no actors to direct. And you certainly don't want to be directing the animals – to film the most natural activity the creatures should ideally not even know the camera is there.

Occasionally the producer or assistant will be on location, and to a certain degree will direct the camera operator. They may be describing what sort of shots they are after, any special effects required, animal behaviour essential to the story of the film etc. But on many occasions a professional wildlife camera operator will be fully briefed and be left to get on with it themselves. Some shots may require sitting in a hide all day just to capture a few seconds' footage – a director would be an expensive, and probably grumpy, liability there!

There are exceptions, however, when directors are needed on wildlife films. In a situation where several cameras are being used for example – the director will determine which camera operator aims to capture certain footage, or angles, or activity and so on. This ensures that the producer and picture editor get the shots they need to tell the story.

Furthermore, with presenter-led programmes, a director is often needed in a more traditional sense – to direct the presenter and the cameras involved. Additional cameras become more likely when shooting a presenter – so there will be more need for a director to control the situation.

Wildlife film directors sometimes come into the job from a production role, and some were previously camera operators. There are also those who specialised in direction from the start but in another field – news or drama for example – and then moved to wildlife production.

Qualities required: patience; an excellent knowledge of camera techniques, lighting, sound etc; the ability to visualise the script and turn this into footage; to know what the picture editor needs to tell the story; to deal tactfully with tired people who may be on the umpteenth take, and thus extract the best performance from presenters.

Case Study:
Yusuf Thakur – Producer/Director
Visual Effects and Graphics

Films: *Wildlife of Bahrain*
Sooty Falcon
Jewel of The Mangrove
Endangered Dugongs

Can a successful full-time Advertisement/Television Commercial Producer actually produce wildlife films? Yes, he can, and in the next few lines, I will explain how.

I have been producing wildlife documentaries for the last ten years and commercials for over 18 years. Five wildlife films in ten years, that's roughly one every two years, commercials over 100 and losing count. I love producing television commercials; they are fun, quick to produce, and the financial means to a decent lifestyle. On the other hand, wildlife films touch the artist in me, no actors, sets, or clients, just you and nature, complete freedom to create. The wildlife films that I have produced have not made money, except the last one, which was commissioned. These five films have given me personal satisfaction and international recognition in the form of five awards, Jackson Hole, International Wildlife Film Festival, Earthvision-Japan, Worldfest-Houston, and Cineciencia in Portugal.

I started my career eighteen years back in India, having graduated in film production. From features to television soaps and commercials, I have had the opportunity to work across the spectrum of film genres. The last seven years, I have lived and worked in the United Arab Emirates; three of my wildlife films have been based in this country and I have thoroughly enjoyed producing them. Most of my commercials I direct and edit myself, but I have written, shot, edited and directed all my wildlife films. One hundred percent involvement and one hundred percent satisfaction: that's what wildlife films mean to me.

I will share one extremely important factor which will help you in producing better wildlife films, and a few pointers regarding filming in one of the hottest places in the world, the Middle East desert.

• Your film should always have a plot/theme/story; yes, it holds true for even a wildlife film. Some times it will be hard to have one, but if you follow this basic principle, you will end up making a better film.

• Extreme heat creates all kind of problems during filming. Equipment failure due to heat and sand can be avoided if you follow a few guidelines.

• Keep yourself and your camera covered: I use a white headscarf as worn by the Arabs to cover my head (worn with a baseball cap, see picture) and a separate one to cover the camera. Observe local attire wherever you film for pointers to protect yourself from the elements.

• Heavy morning dew will clog your tape path and fog the camera lens. Keep your camera covered and remove it in stages from its bag (open the lid or zip a little every few minutes).

• Carry a few zippered bags (clear plastic bags available in the super-market) for your tape/film; these will protect them from all the elements.

• Clean your gear EVERY DAY, even if you have had the most tiring shoot.

• Finally, when you start making your wildlife films, be prepared for disappointment, despair, and frustration not just while filming, but throughout the production, and after a lot of hard work, these films will bring you joy, satisfaction and success.

Will I trade commercials for wildlife films or vice versa? NO, I intend to continue with both.

Cinematographer/Camera Operator

Let's start with a bit of terminology. The term 'camera operator' or 'cameraperson' is used these days to get around the problem of offending some people by saying 'cameraman' (although some of the case studies have used 'cameraman', no sexism is meant, and it is fully recognised that women make just as good camera operators!). The camera operators are the people who physically operate cameras in the field.

A 'lighting cameraman/woman' or 'director of photography' is a senior camera specialist who will decide how the camera operator(s) will work in terms of lighting/lenses/angles etc. In some cases this position is also called 'cinematographer'.

In wildlife film-making, however, it is unusual to have a separate lighting cameraman/woman – usually there is either just the one camera operator or, if several, one of them will take the lead role. Some wildlife camera operators prefer to call themselves 'cinematographers' because they do far more than simply operate a camera. Their skills in using a camera to gather stunning footage and tell a story are the vital ingredient in making a wildlife film.

Whatever they are called, this is certainly the most attractive position in wildlife film-making. When people think of a 'wildlife film-maker' they think of the lone camera operator creeping up on an animal in the bush – not of all the other people who may be needed to 'make' a wildlife film!

Some wildlife camera operators start with a love of wildlife, some start with a love of using a camera. Some may specialise in certain animals (eg big cats) or habitats (eg the Antarctic), or techniques (eg macro or aerial), many are generalists. Many are freelance and own their own equipment – which can be very expensive! Some specialise in underwater wildlife and rarely film on land.

Not long ago 16mm film was almost the only choice for wildlife film-makers; now, with the invention of video, and especially digital video, there is a whole range of other formats – from DV to IMAX. Some camera operators have had to become skilled in using a range of equipment, although there are some who still specialise in a certain format such as Super16 film.

The wildlife camera operator has to be prepared to work anywhere in the world – often in remote places. This is not the holiday it may appear to be – living conditions are often rough, diseases and accidents are commonplace. It can be very difficult to have a family life and sustain relationships (there are a few successful exceptions who take their family with them on long assignments). There are wildlife film-makers who have deliberately not had children for fear that it would impede their careers.

On top of this there is the frustration to cope with when things go wrong. You may follow a certain animal for days and days without getting in the right position for a good shot, or it may never display the behaviour you are after, or it may simply disappear (or die). Not to mention losing/damaging your footage or equipment or having it confiscated by rogue officials! You may spend many lonely and exhausting weeks in the wild and gather only a few minutes footage.

Having said all that, it can be an exceedingly rewarding and exciting job. Spending time with amazing wildlife in stunning settings, truly getting off the beaten track, filming something that few others may have seen – you can't beat it. Usually the hardest part is to get someone to pay you to do this!

Qualities required: skill and knowledge in camera operation and techniques; excellent general knowledge of natural history and animal behaviour; enormous patience; love of the outdoors; ability to interpret the producer's brief and turn this into the required footage; determination and resilience; good health.

Underwater camera operators also need to be skilled scuba divers of course – the actual diving needs to be second nature so that you can concentrate on the filming.

Case Study:
Mark Deeble and Victoria Stone – Wildlife Film-makers
Deeble & Stone

Films: *The Tides of Kirawira*
A Little Fish in Deep Water
Mzima: Haunt of the River Horse

We have been a film-making team for almost twenty years. We met while learning to dive at university – Mark studied zoology at Imperial College, followed by three years researching fish behaviour, while Vicky was next door at the Royal College of Art working towards an MA in fine art photography. Diving brought us together and soon became a passion. Immediately after leaving college, we both knew clearly that we wanted to work with wildlife and water, rather than follow the traditional route our degrees might take us – we just didn't know how to.

Mark worked nights as a commercial fisherman off the Cornish coast, and Vicky taught windsurfing by day – which meant we had to meet at 5am to go diving! At the same time, we both worked as volunteers for a year on an underwater ecological survey of the Fal estuary – we combined skills to take underwater still photographs, which resulted in a book and a travelling exhibition funded by a Kodak bursary.

When the Fal estuary was threatened by a plan to build a container port, with no provision for an environmental impact assessment, we decided that somehow we had to make a film in order to show a wider audience the

marine life and habitats that were threatened. It was a decision that changed our lives – we sunk everything we had into a second-hand Bolex and underwater housing, and with two lenses, set out to make our film. It wasn't easy and it was a very steep learning curve. Family provided hot meals and shelter, and with short ends of film begged from art schools and local cameramen we would go out every morning in our ancient fishing boat to spend the day diving and filming. Neither of us had a formal training in film, but each evening we would borrow a VCR and run classic feature films, without any sound, to analyse their sequence construction and then try and apply what we learnt the next day.

At the same time as we were making what would become *Yndan An Fala – Valley Beneath The Sea*, the BBC Natural History Unit was making a series about Britain. We contacted them and were given two rolls of film with the promise that if we filmed anything that made it into a programme, we would be paid when it did. More importantly, though, Paul Reddish in the BBC was casting a critical eye over our rushes – so we were getting feedback and becoming known within the unit. At the end of that year, when we had taken our film as far as we could financially, we edited together what we had at the local art school and took it to the BBC and then to Survival. Mike Linley at SAL was enthusiastic about what he saw, and persuaded Survival to buy it and fund another season's filming.

The approach we took in that first film has changed very little since. It was to spend as long as possible in the field by living on location, and weave together sequences of animal behaviour to tell ecological stories – to try and explain the big picture through the eyes and lives of some of the smallest.

Alan Root saw our first film and invited us out to Tanzania to work on a Serengeti series that he was producing for Survival. We had been very happy working underwater, but couldn't pass up the chance of working with Alan, whom we considered to be the finest wildlife film-maker, and so swapped our 10mm for a 300mm and our Bolex for an Arri. That initial three-year contract has turned into a fifteen-year fascination with Africa and its aquatic wildlife, and we haven't left yet. The experience has made us as versatile topside as we are underwater and lead us to produce and film our own specials for Survival and National Geographic.

Our advice is: if you want it enough, then get out there and do it – it is not a great time for the industry, but it has never been cheaper to make your first wildlife film. The cost of a DV capture and editing system is less today than what we paid for our first used 16mm camera twenty years ago. Perhaps more importantly – it costs almost nothing to run tape – so you can be more experimental and afford to make mistakes. Analyse what makes a good sequence and a good film. Always try for new or unusual behaviour – it will get your film noticed. Construct sequences and tell stories – great images alone do not make a great film. Spend time editing your material – it will help your filming enormously. Finally choose a subject you know about – preferably in a situation where your expenses are minimal. You might not have any experience but – armed with knowledge, time and determination –

you can produce something that will get noticed.

Case Study:
Nick Gordon – Wildlife Film-maker and Presenter
Freelance

Films: *Tarantula!*
Jaguar: Eater of Souls
Wild at Heart (series presented by Nick)

At 21 years old and training to be a chartered surveyor, I joined a sub-aqua club. I had never handled any type of camera up to that point but it is true to say that my great passion through school and college had been biology and zoology. My first open-water dive was off the west coast of the Isle of Man; I was mesmerised by what I had seen and it was to change my life.

Within two weeks I had found and bought a small, cheap film camera, and built an even cheaper waterproof housing for it. Looking back, the strange thing is that I never considered taking still pictures. What I wanted to do was somehow bring out moving images of those fascinating underwater scenes. I discovered a couple of books on very basic film-making, subscribed to the grandly named Moviemaker magazine, and started to shoot my own stories. I became completely absorbed with producing my short amateur films and quickly moved to wildlife subjects above water – I suppose looking back I was clearly obsessed by almost any animal subjects and the mechanics of putting a film together about them. It was difficult in the early 70s as

everything had to be done on film, and it was expensive. If only today's domestic video systems had been around!

I grabbed any opportunity to film, and one weekend while filming a Riding for the Disabled event I met a chap who just happened to be a BBC television director. I must have come across as a tad keen and, probably to escape me, he said he would be interested in seeing my underwater film efforts. One week later they were shown on television and, as a result of that, I was offered work as a news stringer.

News camera work was brilliant training – even for wildlife filming. Those thirty-second pieces for the evening news contained all the elements that my one-hour TV specials would have one day – I just could never have imagined it then. The work taught me early on that story had to lead the images and that good picture editors were worth their weight in gold to an inexperienced cameraperson! My idea of heaven in those days was to sit behind an editor, watch him work and pick his brains to bits.

My break into our business came through self-belief and determination, even obsession, to become a professional wildlife film-maker. I sometimes cringe when I think back to how I pestered some of those in a position to employ me. For eight years I struggled to make it – often doing small shoots for no pay and no expenses, just to become known and get valuable experience. Things are different today of course. When I finally got my break with Survival Anglia it was enough just to have the passion for your subject and the talent to use a camera. Today, however, you need to be good at business, marketing and negotiating. Thank heavens we have the IAWF. Being able to get together with others who make their living in the same way is perhaps the most valuable thing of all. It is so reassuring that many of the IAWF's most experienced members are always prepared to talk openly and honestly with those trying to get started.

In my opinion there is one fact that hasn't changed over the past twenty years. If you are talented enough and sufficiently focused you can make it happen – but what a slog it can be! After five years of being my assistant, Gordon Buchanan went out into the big wide cruel world of television to try and make it on his own. Two years later he almost didn't have enough money to buy food and was thinking about jacking it all in. He didn't, though. He discovered that he had that extra determination required, and today he is making his own films. I have always believed that if a person is determined enough to do something they can make it happen. Despite the state of our industry at times, I firmly believe that there are still opportunities today to make a career in it.

If you have a good enough story to tell, and are talented enough with a camera, someone will employ you!

Case Study:
Doug Allan – wildlife film-maker/cameraman, topside and underwater
Freelance

Films: *Blue Planet*
Wildlife Special – Polar Bear
Wildlife Special – Killer Whale

(photo credit: Doug Allan/naturepl.com)

I guess I'm best known for my work in cold places, both underwater and topside, but I get called on to film pretty much anywhere. And people as well as animals. Versatility is important – I like the contrast between the get-up-close nature of underwater compared to the long lens skills of topside. The challenge of reading animal behaviour and using field-craft is also in contrast to the different eyes and ears needed when filming people where you may have total control over the situation. While filming makes up most of my income, I've amassed a wide collection of slides as well through the years, and by placing them with agencies like Oxford Scientific Films, I have made some cash as well.

Like many others in the wildlife business, I have a degree in biology, mine from the University of Stirling. It was there that I took up SCUBA diving, and by the time I graduated in 1973 the diving bug had bitten hard. I decided

that science at the sharp end wasn't quite where I sought to be – 'underwater anywhere' became the drive. So for the next three years I worked on various projects: no filming, but some stills photography that helped me develop an eye for composition.

The big break was in 1976 when I went south as a research diver with the British Antarctic Survey. The job entailed helping scientists carry out their underwater studies, from boats through summer, beneath the ice in winter. It was the start of an affair with ice that lasts to this day. Over the next ten years, B.A.S. and I had a great relationship – I spent three winters at one base as diver, and another at Halley at 75° S as Base Commander. Halley's field was ionospherics – but it offered the chance to winter with Emperor Penguins, and a first opportunity for me to turn over with cine film rather than Kodachrome.

The BBC Natural History Unit bought some of my Emperor footage, and my career took a new direction. Using my experience of ice diving, and intimate knowledge of Antarctica through its winters, I proposed two films to Survival Anglia then in 1987 spent ten months down south making them. If I had to sum up how I got my 'break' I'd say that though I was a highly inexperienced cameraman at that stage, I had a special package to offer in terms of the place and animals, and I had low cost access. A very big plus was that I could speak with a high degree of confidence about the potential film-value of the location. I knew what was on offer in the Antarctic: the tricky bit was having the confidence actually to go film it!

Since then, more of the same. You might have gathered by now that I've never actually had a formal lesson in shooting film. I taught myself what I call the grammar of film-making simply by analysing dozens of films literally shot by shot. I ran through sequences of films again and again, listing every shot to see how they were cut together for flow, drama or surprise. That, and reading any sensible simple book on how to make better home movies, will set you on the right path for camerawork. Learn the basics so they're second nature, strive for the best right from your first frame. I know you see a lot of programmes out there that are full of whip pans, tilting horizons, hand-held wobbly bits, ramping (speed changing) through the duration of the shot and other effects. All (mostly) fine, sometimes greatly enhancing the final cut. But shoot that way after you've learned how to do it 'traditionally'.

Learn what you can do in post-production, but don't rely on it to get you out of trouble because you were sloppy in the first place. Start slack and it's hard to change. Try and work with others who themselves have high production values. Sit in on edits, be prepared for criticism then use it constructively to improve your next rushes. Attend Wildscreen, Missoula, Jackson Hole – any of the wildlife film festivals, put names to faces and introduce yourself to others.

Every cameraperson working today would have a different life history to tell about how he or she 'made it'. What they all share is passion and commitment to their craft as their livelihood.

Case Study:

Lawrence Curtis – Still Photographer, Director of Photography, Producer

Curtis Photography, Inc.

Films: *20 Years with the Dolphins* – Cinematography (Hardy Jones Productions – HIT/ National Geographic International ·2002)
Champions of the Wild – Manatees – 1st Camera Assistant
(Omni Productions – 2002)
Animal Crackers – in production – Producer, Writer, Cinematographer
(Curtis Photography – 2001· current)

If one advances confidently in the direction of one's dreams, and endeavors to live the life which one has imagined, one will meet with a success unexpected in common hours.

··· HD Thoreau (Walden)

These words by American writer and philosopher Henry David Thoreau I first read many years ago, and they have been and still are a great source of inspiration for me. I actually have them printed and framed in a prominent place in my office. I read them during times when the phone doesn't ring (which is more often than I care to discuss) as well as after sealing a deal for more work. Good times or bad, these words serve as a reminder to me that I am living my dream. A dream that, despite having been born and reared in land-locked Arkansas in the United States, is a reality today as I am a professional underwater photographer and cameraman working with sharks, whales and dolphins. Truly amazing!

My journey, as it still continues in the early stages, can be attributed to a single word – passion. Every young hopeful must have this in order to maintain not only a position in this field but also their own sanity because of the tremendous competition in this field. If you have passion and it is unwavering then the long hours of training and the good and bad of this or any profession will roll off you like ... well ... water off a dolphin's back.

My background is in the human sciences and while pursuing double degrees in psychology and in anthropology I found my creative side in serious need of exposure (pun intended). Having always been fascinated by the process of image-making, I soon found myself in the darkroom of the photography department at my university. It was there that I cut my teeth on the magic of photography. I began by studying the works of photographers such as Lee

Freidlander and Henri Cartier-Bresson, and soon found that these images were obtained more through the synergy between the photographer's eye and the light/composition relationship, rather than that of the more technical subject/film relationship.

As I began finding my own voice, it was then that I rediscovered another passion from my childhood – marine mammals, especially dolphins. Because I was studying psychology with specific reference to consciousness I soon found myself voraciously reading everything I could on dolphins, inter-species communication as well as hundreds of images – both print and film. It was around that same time that the Internet was becoming predominant and, having already torn through the volumes at my university's library, I started searching the Internet for further information on these subjects. In this wondrous realm of cyberspace I came upon the web site of Hardy Jones, a well-respected wildlife film-maker. But what was most remarkable was that he had produced, with his partner Julia Whitty, a film on inter-species communication with a pod of spotted dolphins in the Bahamas. This was a first-ever film that I had seen several times and had made an indelible mark on my psyche. Amazingly enough, Hardy was offering trips for others to join him in the Bahamas to encounter the very same dolphins that he had been working with in his many films. For me to be In the Kingdom of the Dolphins was truly amazing. Free-diving, unrestricted from the cumbersome tanks and gear, this first experience proved life changing. Seven years later I still cannot put into words that first encounter and have returned every year since to film or just enjoy the dolphins.

Though this first experience helped set the stage I still had a very long way to go. Undaunted, I wrote out a business plan of how to begin this journey of being an underwater photographer. Slowly, I acquired my first underwater camera and began my self-training. Though I held an advanced certification in SCUBA since the age of 15, I felt it necessary to take further courses, eventually working toward a Rescue Diver certification. The point to be made here is that I was a diver (safe diver) first, then land photographer, then underwater photographer/cameraman – in that order. Today, diving, and more often free-diving, is second nature to me. This is mandatory in order to maintain proper camera positioning and control.

My transition into video and film came naturally as this was again a dream from childhood. While getting positioned in the fine art photography world I soon found other types of cameras in my hands: first video then film. Again, my training came from getting the system wet and reading as much as I could on what makes editors happy with camera shots. I also began working with seasoned professionals in all capacities of production as well as helping biologists and researchers in the field. This proved to be, and still is, the best training.

Today, I work out of my office/studio in Naples, Florida. I am still working as a still photographer with all my favourite subjects. On the wildlife documentary side, I am now a confident High Definition Cameraman and am currently making the transition into this exciting new format. My current

projects involve not only local fauna as with the endangered Florida manatee, but also whales and dolphins in places such as the Bahamas, South Pacific and Asia. My work thus far has been most fulfilling as I am helping in the fight for conservation and am proud to serve on the board of directors of BlueVoice.org, an environmental non-profit organization that uses the power of the Internet to help bring an end to such issues as dolphin killings and water pollution by way of films and imagery. I am also a member of Filmmakers for Conservation, and through this group help to support other conservation-minded creatives working in the wildlife documentary world.

The world is a very different place to what I saw on the TV as a child. The underwater world that Jacques Cousteau filmed is being damaged at an alarming rate, and I, along with many of my colleagues, am diligently trying to use the power of imagery to put an end to the destruction of the animals, their habitat and the world in which we all share. This is of the utmost importance so that the new generation of film-makers can continue the legacy that others have, so selflessly, set before us all. This is my most important piece of advice for all who decide to follow their passion in this exciting field. If we don't preserve and conserve our natural world, not only will our subjects go away, but we will too. It is your responsibility as new film-makers to continue this and use the power of imagery to save what is so precious in our world.

So, to paraphrase what our friend Mr. Thoreau said so eloquently – Go out there – Follow your dreams. Live the life as you imagine it to be. Respect and listen to those who came first in the field. Be diligent and educate yourself, not only in the gear, but also in the safety of its use. Learn the behaviour and conservation of the subject matter you hope to work with and you will certainly find yourself succeeding beyond your wildest expectations.

Camera Assistant

The camera assistant accompanies the cinematographer/camera operator in the field and assists him/her in any way that is needed. This can include loading/unloading film, servicing cameras, taking still photographs, recording sound, building hides or tree platforms, constructing sets, carrying equipment, putting tents up, driving, cooking meals and so on.

Pay is often poor or nil, but this is an excellent way to learn the trade if you are hoping to become a camera operator yourself. However it must be said that few wildlife camera operators take assistants.

Qualities required: enthusiasm; willingness to try anything; knowledge of camera and sound equipment operation; still photography skills; driving licence; ability to travel at short notice; practical skills; physical stamina; ability to transform a few ingredients into a gourmet meal on a camp-fire!

Case Study:
Matthew Drake – Camera Assistant
Freelance (and assistant for Hammerhead TV)

Films: *Bears of the Russian Front*
Secrets of a Norfolk Wood

I embarked upon my career as a camera assistant shortly after I completed my university course. I studied for a BSc in Biological Imaging, which involved the study of biology and wildlife documentary film-making, both of which inspired me to become a camera assistant and eventually operator. While I was studying I picked up some good habits, and some bad! The good ones involved watching various wildlife productions and breaking down how the films were put together, paying attention to the different shots used to make up sequences and looking at the infinite ways stories could be told. Being a student you have a certain amount of free time on your hands, so I began to make contacts within the industry in an attempt to pave the way for when I graduated. This was achieved by noting down the names of camera people, producers, and the production companies they worked for, which were all available in the credits at the end of each programme.

Fortunately for me, the year I graduated was the year of Wildscreen 1998. I had missed out on the opportunity to attend as a volunteer so I paid for just two days, which was all I could afford at the time. My main goal when I was at the festival was to put names to faces and speak to as many people as possible. The preparation of my CV and contact details was important, as most of the delegates you need to speak to are usually busy themselves. Attending such events is a brilliant thing to do, as I came away from Wildscreen with a greater determination to succeed in the industry.

I eventually received my first break as a result of Wildscreen. I had managed to pass on my details to a producer working for Survival Anglia, who in turn passed them to a cameraman who was shooting a documentary in Norfolk. We spoke over the phone and he asked me whether I would like to come and help out on the production, to which I happily agreed. The budget for the production was quite tight so I worked for free, which is always a positive thing to do when you are starting out. By the end of the job I had made new contacts, gained experience and, most importantly, earned a good recommendation that resulted in further work with Survival Anglia as an assistant.

The next project I worked upon came about through information given to me by the cameraman I worked with on the previous job. He had given me the names of a very experienced husband-and-wife camera-team who possibly needed an assistant for a production they were researching. With this information I set to work on contacting the team: I forwarded my CV and then followed it up with a phone call. I managed to get an interview, which eventually led to me getting the job. The project got the go-ahead from Survival so we all set about preparing for the job. As I was still relatively green I spent a fair amount of time staying with the camera-team at their home getting to know them and all the equipment, which proved invaluable.

The project involved eleven months filming grizzly bears in Kamchatka, Far East Russia. My main tasks as an assistant involved a whole range of duties from making the tea (very important!) to sound recording and stills photography, so gaining skills in any of these areas will help you on the way. Having a flexible approach to any situation also, is one of the key elements involved in being an assistant because you never know what will be required of you.

When presented with a project you soon forget about all the time and effort you had put into prospecting for work, i.e. the letters, phone calls, emails etc because it makes it all worth it. Wildlife film-making is a difficult industry to break in to, so try and remain focused and positive, as the rewards can be truly inspiring.

Sound Recordist

A surprising number of the natural sounds you hear when watching a wildlife film were not recorded on location (more about this when looking at the work of the dubbing mixer later). When filming animals at long-distance it is almost impossible to record the sounds of the action. The sounds of the cheetah's paws will be completely overwhelmed by the millions of insects in between the microphone and the action, not to mention the wind.

Recording sounds underwater is also problematic – sound travels much further in water than in air – so it is tricky to catch the sound of a fish munching a shrimp when you are bombarded by the sounds of the waves, ship engines, distant whales singing etc.

Having said that, the plan should be to catch as much location sound as possible for the dubbing mixer to work with later. This location sound is sometimes recorded by the camera operator at the same time as filming, but better results are usually achieved when a specialist sound recordist is used. Microphones attached to cameras are rarely satisfactory, and will pick up camera noise as well.

The sound recordist will operate a variety of equipment to capture the sound – recorders such as portable DAT (Digital Audio Tape), a variety of

microphones for different applications, parabolic reflectors, boom arms etc. The sound may be recorded separately from the camera operator, or be recorded on to the camera's video-tape sound tracks – in this case the sound recordist will operate the microphones and a small mixer which then feeds into the camera. This enables the camera operator to forget about the sound and concentrate on the picture.

The sound recordist needs to be adaptable and get good results whether recording a talking presenter who can't stop leaping about, the barely audible sound of a beetle grub munching through a log, or the soundscape of a night in the jungle. He/she will have to put up with the same living hardships as the camera operator.

Qualities required: good hearing; good knowledge of audio engineering and sound recording equipment; patience (with the camera operator!); ability to work in a team; skill at improvising techniques; willingness to work in any conditions.

Case Study:
Chris Watson – Wildlife Sound Recordist
Hoi Polloi Film & Video

Films/Productions: *The Life of Mammals* (BBC TV NHU)
Talking to Animals (BBC TV NHU)
Soundscape– A Swallow's Journey

I'm a sound recordist with a particular and passionate interest in recording the wildlife sounds of animals, habitats and atmospheres from around the world. As a freelance recordist for film, TV & radio I specialise in natural history and documentary location sound together with track assembly and sound-design in post-production.

Like many of us in this business I developed a keen interest in natural history as a teenager, and was inspired one Christmas with a gift of a portable tape recorder from my parents. I fixed the microphone on to our garden bird-table with the recorder at the base – and was captivated by the results. From there I became fascinated with the idea of recording animal voices and eavesdropping into those secret worlds and their communications. So I'm one of those very fortunate people who have a hobby which developed into a career.

During the late 1970s I worked in a band and in music recording for several years before, in the early 1980s, writing to every TV station in the country. I fancied working to try to gain experience of film sound as a way into natural history programme-making. During that period there were many ITV & BBC stations recruiting and training staff and I was fortunate enough to be offered a place training in the sound department of Tyne Tees Television in

Newcastle-upon-Tyne. I spent four years in independent television learning some of the art and craft of TV and film sound on a wide range of productions from news gathering, outside broadcast, drama, documentaries, music shows such as "The Tube" as well as dubbing work and post production. During this time I was also building up a library of wildlife sounds and gaining valuable fieldcraft experience everywhere from my home in Northumberland to exotic film locations, from Africa to the Caribbean.

In the mid 1980s I was offered a two-year contract as sound recordist with the Film & Video Unit of the Royal Society for the Protection of Birds (RSPB). This was a dream ticket for me to have the opportunity to establish, record and document a wildlife sound library for all their productions. Many well-known people in our business have worked their way through the RSPB Film and Video Unit and it was a real pleasure and privilege to be part of a small team of such hard-working, knowledgeable and creative professionals producing films to such a high standard. Working in a small team with added responsibilities, together with time and budget constraints can be frustrating, but it can also stimulate creative results. Try it!

Wildlife and natural history programme production is now much more varied and competitive so I would suggest that production experience in virtually all areas and types of programme making is useful. Indeed many recent productions have benefited from the refreshing style and creative influence brought from other areas such as drama and documentary. I feel the incorporation of some of these better ideas, together with strong production values, will help wildlife film-making move successfully into the 21st century. However, good fieldcraft, common sense, humour, patience, stamina and flashes of genius are still required on location – and I guess through life! Remain true to your ideals, stay behind the camera and get some great wildtracks!

Case Study:
Joe Knauer – Sound Recordist
Freelance (Magic-Sounds)

Films: *Fragrance of the Forest* (ORF)
The Magic Trees of Assam (ORF/ZDF/Doc-Star/National Geographic/
Canal +)
Ancient Amazon (ORF/ZDF/Doc-Star/Canal +)

Nature's not Silent

I am a sound recordist and live in Austria. In 1992 I had my first glimpse into the business of sound recording – at the time I was working as a camera assistant and sound recordist in an ENG-team (Electronic News Gathering). I realized that sound really fascinates me. After a few projects as sound recordist came the first natural history programme, a three-part series about bears, birds of prey and red deer. I was surprised how many of the images were actually shot in a zoo, and when the films went into post-production we had to dub those shots and a lot of the library footage. Sounds for a deer giving birth or a panda eating had to be produced in the studio. I sucked on a wet towel and instead of Eucalyptus I ate my Benjamin Fichus! On this project I spent more time in zoos and sound studios then in real nature. I hadn't imagined natural history film-making would be like that. But I had put my foot in the door – I had made a start.

The next project was completely different: *Fragrance of the Forest*, a two-part documentary about the different kinds of forests in Austria. For weeks on end we would see hardly anybody; we became one with the forests, and there was silence around us, which we breathed and lived. Stereo sound recording was state-of-the-art and because we did not have to do any sync pieces I was able to record an encyclopaedia of the sounds of forests. In all parts of Austria, at different altitudes, different times of the day and during all four seasons, I went through the forests with my Nagra and felt, listened and recorded. What a beautiful time! When we did the sound edit I had to exchange the freedom of the forest for the limitations of the sound studio, but as I had recorded so much sound we could really work out of a vast repertoire. We were able to play with moods and that made it possible to give the pictures the life that would transfer the viewer into the forests.

Again and again I hear and see that natural history films are without original sound. A flood of beautiful images accompanied by music, in my opinion,

distances the viewers. We show them these pictures on screen, but we do not take them with us on this beautiful journey in a foreign world. Visuals and sounds have different rules. A high-voltage electricity pole, a road or other signs of human presence do not disturb the cameraman who captures the environment, as long as he can keep them out of frame. That is very different with sound. A road that is close, but not within frame, is a real problem for recording sounds. When we are at home and watch a film it is the opposite; the image is limited to the screen but the sound can help to cross this border between the screen reality and the attention of the audience within a living room. Sound can help to transfer the viewer into the silence of the great deserts, the humidity of the rain forests. It can make them live a thunderstorm or a lovely spring evening, and even hot and cold temperatures can be felt!

All this I was able to experience on another project: *The Magic Trees of Assam* – which really challenged me. Giant honeybees that live 150 feet up in trees! In the beginning, I thought, "What should I record except the boring sound of humming bees?" But after I learned more about the lovely beasts, I became aware of their acoustic potential. Sounds within the bees' nest, defense behaviour with their acoustic warnings, a swarm that takes to air, a single bee collecting honey, an attack on an enemy, the cleaning of raindrops from their wings. All this I wanted to record. But how? Whenever I disturbed the bees, they would attack my microphone and it sounded horrible. Then I realised, that I had a black skin on the boom and that these bees attacked everything that was black and moving. So I took a white piece of cloth and put it over the boom. So they did not attack the microphone, but instead they attacked me... aaaaaa...! Then the stereo microphone was too big, so I built myself a small X/Y microphone (I could even put on blooming flowers), and therefore I was able to deliver the sounds to the macro images of the camera. The environment around the nests, the birds, wind in the trees, an Indian wedding ceremony – everything was louder than the bees and caused me problems, but when the camera got closer and closer into the nests, I really got into trouble! How should I record the behaviour of a single bee sitting in a crowd of another 120,000 busy bees? I took an MKH 416, a small tube, some foam and funnel and built a "macrophone" out of it, and so I was able to record the sounds I needed from the inside of the nest.

Our job is never boring: we are confronted daily with new obstacles, challenges and dangers. But the most beautiful award for me is that I can get away from city life, that I can get back out into nature to listen, to listen to the faintest sound, to record it and to take it with me.

Nature's not silent. Nature's got so much to tell us.

Presenter

A major trend at the moment is for programmes with on-screen presenters, and there is no end of budding David Attenboroughs and Steve Irwins wanting to give it a go.

There are many different styles of presenting wildlife programmes – each with its merits (and critics!). Some presenters are serious and in awe of the wildlife, some are very matter-of-fact, some are wacky and lark about (especially for children's programmes), some are relaxed and friendly, others grab any animal they find and thrust it into the camera lens.

The reason for a presenter's presence is to provide the viewer with a link between them and the wildlife – to help explain what's going on, and to help the viewer feel closer to the wildlife. Also to embody a voice, provide scale, and lend authority by 'being there'. Some presenters are specialists, or actors, or ex-camera operators. Others combine several roles – there are producers and cinematographers who also present programmes.

Presenters need to be calmly able to do several things at once. They need to be able to remember what they are saying, how they are saying it, where they are looking, whether they should be smiling, possibly while holding an animal, maybe walking while looking at the camera, being aware of the producer/director making hand signals and so on. It's not easy – it takes a lot of practice to do this without eyes that are bulging with fear and stress!

They need to be able to say the same things over and over again without losing enthusiasm. Take twelve! Doing this next to a grumpy eagle that looks as if it fancies your eyeball as a snack can be a strain... .

Qualities required: excellent knowledge of natural history (a degree often favoured by employers); confidence; enthusiasm; engaging personality; good memory; clear speaking-voice.

Case Study:
Miranda Krestovnikoff – Presenter/Researcher
Freelance

Films: *Smile* (CBBC)
World Gone Wild (Fox Television)
RTS award-winning *Water Warriors* (Carlton)

Before doing my degree I didn't really know what I wanted to do as a career. I had ideas ... but little direction. I read zoology at Bristol University and in the summer of my second year I decided to stay in Bristol over the holiday and find some work. My tutor suggested I try the BBC Natural History Unit

(NHU) and I managed to get a couple of months of animal husbandry work for a "Natural World" film. The work involved becoming an instant expert on frogs and toads – I had to look after twenty or thirty animals that were shipped in for some studio and location filming. It was great fun but I did a lot of work for next to nothing – something you need to get used to when starting in the business!

During my time on this project, I worked very closely with the cameraman and he gave me lots of advice about people to speak to about getting work-experience in the industry. This is really the only way to get work as a researcher and I managed to do a few weeks of work-experience before I even took my finals. I was lucky that I got ahead of most of my friends who wanted to do the same thing, as they mostly started their hunt for work after their finals finished – so I was already a year ahead of them.

I spent many hours during my final year at university on the phone, writing letters and watching the credits on wildlife films so I would then ring up the producer and go in for a chat and could talk about his/her film. By the time my finals were over, I had a job offer on a major BBC NHU series as a runner and from then on it was just a case of bumping into people at the BBC, more phone calls and sending out CVs.

Be warned – there is a lot of hard work involved in even getting work-experience (unpaid!) let alone getting your first job; and having had a job doesn't guarantee you getting another one when your contract runs out. Behind you there are hundreds of people in the queue for your job so you always have to remain on top and be willing to sacrifice life for work. The best tip I was given was that for every researcher job there might be 500 or more people on the list. You get the job only if you are number 1 on the list, so how do you get there? List your attributes and experience and see if that puts you ahead of the rest of the candidates – if not, go and get more experience and create opportunities to push yourself higher up the list until you're at the top: then you get the job!

For me, the move from researcher to presenter was fairly painless. I had always wanted to be in front of the camera but it's hard to find the opportunities to get the chance to do it. I did a couple of official screen tests and also sat at home and 'played' for hours in front of my camcorder and then checked it back. My lucky break came when an email came around

from Fox TV asking for new presenters on a wildlife series – so I auditioned and got the part.

Since then it's been up and down – with work and with agents. Presenting is a really hard job and being specialised makes it even harder : it limits the amount of work you have the potential to do. It's really fun when you are working but there's a lot of competition for each job. If you think life is uncertain with contracts as a researcher, then it's far worse as a presenter! Good luck!

Narration Script-writer

Scripts for a presenter to speak will be written during the pre-production and production phases, while those for the narrator can be written beforehand as part of the story-building exercise, or after production when the writer knows what footage is available.

Constructing the story in words is a very valuable addition to the film: it can change the whole experience for the viewer, provide tension, fun, drama etc. Producers sometimes write their own scripts but, unless they are skilled writers, they then need a professional narration script-writer to go through and improve the script – known as 'polishing'. Better to work with a professional script-writer from the start.

The writer needs to research the subject thoroughly, immerse himself/herself into the film, and work with the producer and the editor to provide a well-paced script with the necessary amount of information and dramatic content suitable for the production.

Qualities required: excellent knowledge of natural history; ability to weave a good story from a collection of seemingly unrelated bits of footage; research skills; ability to write to a deadline.

Case Study:
Beverly Brown – Independent Producer and Writer
Beverly Brown Wildlife Films

Films: *Sex & Greed.. the Bowerbirds* (Natural History New Zealand Ltd) *Australia's Dingo Island* (Partridge Films)

As a writer for wildlife films you need equal measures of passion and patience. When your work is dismantled by a "committee" that cannot understand the finer nuances of your masterpiece you need the forbearance of a saint. It is passion that gets you through. Believe me, when everything finally falls into place, and you hear *your* script spoken by a good narrator, it

is worth every bit of the angst.

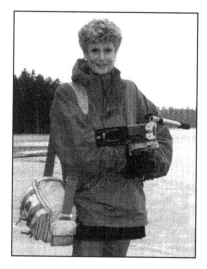

My journey towards becoming a writer began over twenty years ago, with a summer job in the Contracts' Department of the BBC Natural History Unit. I didn't realise it, but I had fortuitously put a "foot in the door". Later I wheedled my way into becoming a field assistant for a crew going to the Arctic. I couldn't differentiate between lenses, hadn't the faintest idea how to load a magazine, and kept jamming my fingers in the tripod, but I had found my niche! When a BBC producer asked me a few questions about my home country, I somehow convinced him that my research skills were second to none, and then for six years I researched, and worked in the field.

Perhaps the most important thing that happened was the realisation that my research notes were being used verbatim in final scripts, and I began to wonder if I could become a writer. It was difficult to get started, even then, so I decided to become a producer and write for myself. It took an age to gather up enough courage to ask for a chance. In this industry, if you don't ask you surely won't get, and I can only encourage you to speak up for yourself. Although I love writing for my own films, increasingly I seem to be producing and writing other people's ideas.

During the last two years (1999–2001), the dynamics of wildlife film-making have changed enormously, and many experienced people are struggling to find work. For a newcomer who is desperate to write, getting a break can seem hopeless, but there are a few things you can do to help you succeed.

• If you are not doing so, start writing *now*, and get a small folio together. You need to be able to show you have some experience, and enthusiasm, and that you can use language in a creative way. Seek opportunities for research, magazine and newspaper articles, brochures and publicity, reviews, anything that keeps you writing. And if the work has wildlife or outdoors themes, so much the better.

• Attend every writing/film-making course you can. Find these through creative arts' web sites, adult education programmes, polytechnics, and the like. Make www.wildlife-film.com your home page.

• If you can afford to, go to film festivals and seminars like Wildscreen and Jackson Hole. Be present where wildlife film-makers gather, and network! Take a deep breath, gather courage and introduce yourself. Make appointments to talk to people and ask their advice (write thank you notes).

Join your Writers' Guild. Create yourself as a writer.

• Watch many films. Beg and borrow cassettes. If you love the words, find the producer and ask for a print-out of the script.

• Religiously follow up leads, while aiming to *Get Your Foot In a Door*! This is where the opportunities are – they are seldom advertised outside. Check the wildlife-film.com website and newsletter. Research is the best option, but be prepared to tackle anything and be cheerful about it. Keep asking.

• Feeling deeply about wild places, wild creatures, different cultures, and the joys and dilemmas involving all of these, makes for spirited, heartfelt writing. Writing is something internal that flows outwards, and is enhanced by interests away from a film environment. Whatever moves you and soothes you – do it!

• If a chance in a film company comes your way, be it writing or not, be realistic about what you can achieve – egg on the face is not attractive – but do accept a challenge. Then meet your deadlines. Value and respect your colleagues. Argue for your principles by all means, but take grievances to the right person. Do not be a lunch-table whiner, and if you are a drama queen, join repertory. There is a lot more to script-writing than getting pretty words on to paper, and if you are an opinionated pain, or precious, you won't get another chance.

Waiting for your chance in the sun is a frustrating, often painful and lonely process. Quiet arts such as imagery and meditation can help you hold your vision, as can finding a mentor, a close friend, or a discussion group to support you. Finally – if you resent the work you currently do, but need the income, rearrange your thinking right now. Your current job is simply the first step on your journey to becoming a writer. Trust me, I know...

Case Study:
Brian Leith – Independent Television Director/Producer
Director of Scorer Associates

Films: *Congo* (RTS Award for Best Science/Natural History Programme 2002)
The Natural World: Elephants of the Sand River (Two Panda Awards for Photography and Music at Wildscreen 2000)
Africa's Big Game (Best of Festival, Missoula IWFF 1996)
(All for BBC)

In 1978 I was writing up my PhD (on the evolutionary genetics of the land snail Cepaea nemoralis!), determined not to end up on the dole. I saw a job in the BBC NHU advertised in New Scientist and sent in a rather rude application form (they asked for my 'grandmother's maiden name at birth'

and I told them this was just plain silly...). Of course I expected to hear no more – but they gave me an interview (advice No.1: try to get noticed) and much to my astonishment I was offered a job as 'junior' producer in BBC Radio. I started producing weekly programmes for Radio 4 like *The Living World*, *Science Now*, and *Medicine Now*.

At the time I felt that radio was the 'poor relation' of television: smaller budgets, less prestige, no pictures! All of this was (and still is) true. But I picked up some very valuable skills, often overlooked in TV circles: writing and story structuring. Because radio is all sound and no picture you have to learn how to capture people's imagination without the help of arresting images. And you have to learn how to tell an engaging story: what's the 'in'? (always: cut to the chase). What's the meat of it? How long is it worth in your programme? What's ingredient 'x': the 'take' on the subject that will grab the audience? When I left radio George Fischer, the eminent Head of Talks and Docs in London gave me some sound advice: "Never lose your writing. Even in television, it's all about writing".

In 1983 I started working as a researcher/director on the BBC's first wildlife/environment magazine series *Nature* on BBC2 TV. I found the first few years working in television frustrating: I felt inadequate in terms of directing, photography and editing, yet at the same time disappointed at the wildlife film-making obsession with 'great images' but disregard for simple story-telling. I've been slowly trying to marry the two in my own work ever since.

Writing for television is about feeding the 'other half' of the viewers' brains. Pictures go in one side – powerful images which tell their own literal story (sometimes despite the script if you're not careful). The words should go in the other side, feeding the imagination and the intellect – to create a double whammy, hitting the viewer with both barrels as it were. Music is another powerful tool that reaches yet other parts of our brains: the instinctive and emotional. I feel we're still just exploring the edges of the mental territory reachable through this combination of pictures, words and music. At the moment feature films do this best, but we documentary makers shouldn't be afraid to use emotions in our films!

Here are the commandments I try to follow when scripting a film: brevity is the soul of wit; lack of clarity is a sin; pretentiousness is a crime.

My advice to newcomers is:

• If you're coming to the business with ideas of glamour or money go back and think again. Only a love of what you're doing will carry you through.

• Bring your own expertise, fascination, even obsession to the business. Have something to say, a story to tell, a place you love, an idea you're dying to talk about.

• Don't be afraid to be different, to have an unusual perspective or approach. The world's dying of homogenisation.

• If you're going to succeed in television (or radio, or journalism, or any medium) you have to enjoy communicating. Enjoy listening. And enjoy talking. It's a two-way street.
• Have faith! If you're determined, you'll succeed.

I once asked a talented writer friend how he did it. He replied, rather witheringly: "I just get on with it." That's what we all must do: give it a go. Write that proposal!

Case Study:
Jeremy Evans – Writer

Films: *The Great Dance*
Living with Dinosaurs
Natural World: War Wrecks of the Coral Seas

"A story is like the wind, it comes from a far-off quarter ... I sit, merely listening, watching for a story which I want to hear, that it may float into my ear."

(//Kabbo – Bleek and Lloyd, 1870s)

Jeremy Evans wrote the script for the extraordinary film *The Great Dance*. The film deals with the unique relationship between the San people, or bushmen, of the Kalahari, and their environment, seen through the experience of hunting and tracking. Specially-adapted mini-cam technology and never-before-seen footage of the death-defying 'chasing hunt' make the film a unique and remarkable experience. The film has won a host of awards including the WWF Golden Panda Award for the best entry overall and Production Crafts Award for best script at Wildscreen 2000, and Best of Festival and Best Script at the International Wildlife Film Festival 2001.

There are two unusual aspects of this film: that the San don't see themselves as separate from Nature in the way we in the west now do – ie that natural history excludes humans; and the San people are equity partners in the project, with a share of the profits going to them – rather than the usual rip-off by westerners with silver boxes who come, take pictures and leave forever. Another encouraging thing about this film is that

it was made by a small number of independents/freelancers without the backing or resources of a major broadcaster.

The Great Dance (www.senseafrica.com) was produced and distributed by Ellen Windemuth from Off the Fence (Netherlands – www.offthefence.com) and directed by Craig and Damon Foster from Earthrise/Liquid Pictures (South Africa). Executive Producer was James Hersov. The following is an interview with Jeremy Evans specifically about this film:

"In the beginning was not the word, but the picture. While this is not unusual for a writer of factual programmes, what did prove unusual was the lengthy and detailed process by which the script was to be distilled out of a mass of transcripts, books, poems, and academic sources. The narration is, in fact, more like a radio play assembled from quotes made at different times by !Nqate and his companions, or known explanations by other bushmen.

"In early 1999 I saw a tape from the first shoots. The images had immense power and beauty, but I felt at times it would be difficult for a Western audience to grasp what was occurring. I am a typical British viewer: I have scant experience of Africa; little knowledge of animals or hunting; none at all of tracking. I showed the pictures and a draft script to a friend, Rob Harrington, an award-winning editor and composer. He tossed the pages aside and watched in awe. I knew then we were in the presence of something special. The producer, Ellen flew me to her office in Amsterdam, where we went through the tape and noted down my comments on extra material needed to flesh out the film, to help urban viewers grasp the way animals made tracks. We had to find a clearer way to structure sequences to show what the hunters saw from the spoor. I also wrote fresh questions for the brothers to put to the San.

"Craig asked me to write the film in the first person. I was extremely reluctant to do so. If, even for one second, the audience ceases to believe that the main character is narrating the film, the overall effect is ruined. I had transcripts of everything !Nqate and the others had said the previous November and the replies to new questions after Craig and Damon's second trip in September 1999. They were already working with the contributors more closely than many film-makers can afford in time or effort. We decided that I needed to go to South Africa to spend time in the offline edit suite – and for a crash course in bushman beliefs. I was able to question them repeatedly about events in the hunts and San lore. I had access to the little bushman literature that exists – chiefly the accounts written down by the linguist Wilhelm Bleek questioning the /Xam //Kabbo in the 1870s. I returned to Britain with a better idea, more questions and a stack of worthy tomes (eg. George B. Silberbauer, *Hunter and Habitat in the Central Kalahari Desert,* Cambridge University Press 1981 ISBN 0521 281350). After considerable delay, I wrote drafts throughout January and February of the next year.

"The process of writing mimicked the hunt itself. To capture !Nqate I had to know him and what he was thinking at any point. Not what I imagined he

would be thinking, but what he or one of the others actually thought. He and his companions had taken the film seriously for the first time when they saw from a first assembly how accurately they were being portrayed. When the team took the risky, and again unusual, step of returning to the Kalahari to find them, the master-hunters were waiting for them, ready to give lengthy explanations of what they were doing and thinking. These later joint viewings of the rough and fine cuts allowed the narration to be based solidly on their words and thoughts. The film's structure (three main hunts) and repeated speech ("women like meat"," taking without asking", "tracking is like dancing") mimic patterns in which the San explain or tell a story. The layers build up so that new meanings of the same phrase become possible.

"We had set ourselves some severe constraints. I could not introduce anything !Nqate did not know – eg. that this hunt had never been filmed before. As a result, I could not make comparisons with Western concepts – or use words like hospital, clock or degrees of heat, items that would be alien to him. In a parallel with the hunter and his prey, I felt I had to become !Nqate. Only when his heart beat in my heart would his words flow. But to reach the point of seeing through his eyes, following him through thickets of dialogue and thorny passages of translation proved long, mentally demanding and surprisingly arduous physically.

"I was kept on the right track by constant review of the drafts. Ellen and James read and commented. Craig saw where I was heading, guided me away from the worst pitfalls and marshalled helpful pointers from academics Tony Traill, Dr. Janette Deacon, and Megan Biesele. It was a very rewarding process, more dramatic in technique than most documentaries. I felt we had achieved something extraordinary when Sello, the actor who plays the voice of !Nqate in English, was overcome by emotion while recording. In the end, the words are a luxury: if Amazon Indians can grasp the essence of the film without translation the force is in the images. But for most of us they are essential signposts in unfamiliar territory."

Narrator

The narrator is the unseen voice that talks you through the film – engaging and informing the viewers – and hopefully not annoying them and detracting from the visuals.

Narrators are usually either professional actors/voice-over artists, or the cinematographer who made the film, or the off-screen presenter. Occasionally the producer will also narrate the script.

The narrator needs to be able to interpret the script and deliver it with the correct pace and emotion. This is either recorded to the picture, to timecode, or sometimes recorded separately and matched to the footage later by the picture editor.

There are many different styles of narration – you either have a set style, or are versatile enough to suit different styles of film. There are those who are very laid-back and relaxed, those who are incredibly enthusiastic, those who whisper in awe, those who are emotion-builders and so on. Some producers have favourite narrators who become the 'voice of the series' and are used time and time again.

Qualities required: a voice to die for; the ability to interpret the producer's directions, read a script to a certain pace and tell a good story in an engaging manner; unflappability and calmness in a studio environment.

Case Study:
Malcolm Penny – Narrator and Script-writer
Freelance

Films: *Cry of the Wolves* (Afikim Productions, 2001)
Messengers of the Spirits (ZDF, 1999)
A Century of Terrorism (SET Productions, 1998)

Barry Paine once said that if you want to be a narrator, and you haven't trained as an actor, a very good start is to be a singer. He was right, as usual. Narrators, like singers, try to make noises that people will enjoy listening to. I have been a singer all my life.

Survival's policy (remember Survival?) was to use actors as narrators, but all of us writer-producers recorded our own pilot commentaries, and I always enjoyed doing it. The practice was valuable later: when we made a half-hour about the effect of the oil spill in Kuwait (*The Tide of War*, 1991), the news was coming in so fast that I had to record the commentary myself, on the day before transmission. I had done a couple before that (*What Killed the Seals?* 1989; *Before the Oil*, 1990: I seemed to have become the oily voice of Survival), until I became one of the first casualties when the Hollick slick

overwhelmed the company.

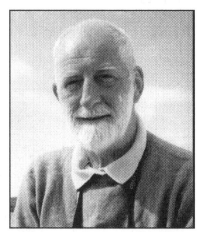

After twenty-odd years, and about 150 completed programmes as a writer and producer – and at fifty-one years old – I couldn't imagine what to do next. Then Reinhard Radke of ZDF suggested at Wildscreen that I translate some programmes into English for their international versions, and record the narrations. I bought a huge German dictionary, and my new career had begun. A little later on, I was recording some voice-overs for Afikim Productions in Jerusalem when a flatteringly-excited producer – Dan Setton, of SET Productions – overheard the session, demanded my card, and offered me work. Shortly thereafter, I read some commentaries for ORF (Austrian Television), and even three half-hours for BBC East, one of which went nationwide. The biggest operation was a programme for IGEL Media in Germany, about the lives in South America of the crew of the Graf Spee (*Frozen in Time: Children of the Graf Spee*, 2001). That needed more than twenty other voices as well as the narration. I did some myself, but hired a couple of actors to do the rest, and a hilarious time was had by all. IGEL seemed to like the result.

My tally to date: I've lost count of how many ZDF hours and half-hours; a series of half-a-dozen or more very serious programmes about terrorists and suicide bombers for SET; some one-hours and half-hours for ORF; those three half-hours for the Beeb; and some highly technical lecture films for Gerald and David Thompson of World Educational Films, based on the work we did at Oxford Scientific Films from 1981–84. And more to come, I hope, because I have found a way of earning a living that I enjoy as much as anything that has gone before.

I still write scripts, mainly for Afikim, and until recently for HIT Wildlife in London; and I enjoy acting as a script doctor for anyone who asks for my advice. Nikhil Alva sent me his excellent film about the lions of Gir, and I was delighted to make a few suggestions about the script.

To any aspiring narrators out there, here are a few tips – just so long as you don't take over all the work on offer.

• Know the script before you enter the studio. Work through it as if it were a musical score, marking emphases and pronunciations.

• If you can, record the narration wild, rather than to picture or to a time-code. I work with Rory Fitzgerald, in the studio his father Paul set up in their back garden in Norfolk. We use Sadie, so that we can clean up the voice-over and lay it to the picture after recording. This takes time, but Fitz's studio is

not expensive, and it produces a much better result. We do re-takes as we go along.

• Develop a style of your own. Mine is quiet and close-up. I used to hate headphones, but now I use them all the time, to judge what the innocent victims out there are going to hear.

• Don't declaim; you are not speaking to a vast crowd on a mountainside. Address an individual person. You might need to alter the script in places to suit your own style. Hope that your producer can hear the value of this.

• Don't be afraid to sound enthusiastic, awed at times, even amused – but a long way this side of Rolf Harris. The audience doesn't need to be told what to feel, but it helps to hold their attention.

Narrating wildlife films is fun, full of interest and reasonably well-paid. I'm glad I spent all those years at Survival, but I wouldn't swap my present position for anything.

Music Composer

The background music is often overlooked as an important creative element that can change the whole feel of a film. Music can build tension, drama, surprise, humour, sadness, or can be relaxing or uplifting.

Music is either composed especially for a film, or the rights are obtained for existing recordings, or it is bought in as library music. Library music is usually the cheapest option – but much of it is dreadful, and it is hard work finding the right music to fit in with the film. Previously-recorded popular music can work well – for example BBC's *Spiders From Mars* – which used contemporary music to great effect and won an award for Sound Design at Wildscreen 2000 as a result.

There are many different styles of music found in wildlife films – some specialise in unobtrusive atmospheric washes, some go for the dramatic highs and lows (a lot of crashing highlights can cover up a lack of natural location sound). Others prefer more contemporary styles – especially for magazine-type programmes.

Music can be played by real orchestras, or by a small group of musicians playing conventional instruments, but increasingly commonly it is produced by a single composer using the latest keyboards and samplers. These are often used in the composer's own home studio where a computer is used to sequence the keyboards and multi-track the instruments. Since the arrival of MIDI (Musical Instrument Digital Interface) in the 1980s, the possibilities for the lone composer have expanded enormously. Home studios are the favoured option as composing in a professional studio which is costing a lot

per hour can be very stressful.

The music is either composed 'blind' – in which case you would write, say, thirty seconds of music to fit in with a certain sequence from the film – and then leave the picture editor to match it up later – or composed in sync with the pictures. To do this the composer will have a video monitor in the studio that is synchronised to their multi-tracking computer or tape recorder, using a timecode such as SMPTE (Society of Motion Picture and Television Engineers) to keep the picture and sound locked together accurately to within a fraction of a second. This enables the composer to match certain musical sequences exactly with movements – tinkly notes as a crab runs across a rock for example – each note coinciding exactly with the footsteps of the crab.

The important factors are to make the music add to the emotion of the film where necessary, and never to let it get in the way of natural sound or narration.

Qualities required: excellent musicianship in a number of different styles; ability to interpret the producer's wishes and apply the required amount of emotion to the visuals; your own equipment/studio preferably; an understanding of animal behaviour; the ability to compose to a deadline.

Case Study:
Victoria Arlidge – Composer
Making Tracks

Films: *Horse Tales* (The Discovery Channel)

Animal Antics (Channel 5. Bafta nominated two years in a row)
Insect Antics (Channel 5, in production)

Composing for wildlife programmes can be extremely rewarding for those involved because in general there is likely to be a lot more space for music than there is in the average programme. Similarly, as wildlife programmes tend to have narration rather than dialogue, there are likely to be more places for large sections of music to be played at a decent volume without sound effects or spoken word getting in the way! The most enjoyable wildlife series I did was called *Horse Tales* which consisted of six sixty-minute programmes, each set in a different area of the world. For each

programme I had to compose in a completely different style: African, Irish, Classical, Country etc, some of which were styles I'd never written in before. The variety of this job and the fact that I was learning new compositional skills with each programme made it extremely enjoyable.

My first television contact was made at a party. A friend of a friend was making a wildlife series and was looking for a composer. She wasn't happy with the music that had been written for the pilot of the series, as the composer had not used any 'real' acoustic instruments in the soundtrack. She overheard me saying that I always liked to include at least one live instrumental recording in a soundtrack as I was an instrumentalist myself, and this led to her asking for a demo of my compositions. She enjoyed listening to it and offered me the series. It was one of the tightest deadlines I've ever had – I didn't leave the house for weeks – but it led to a second series being commissioned. On this second series I worked with another director from the same company. The original director moved to a different company but commissioned me to do another wildlife series with her new company – in other words my contacts had doubled! I am now working with a third director from the original company: thus contacts can grow organically.

Making contacts can be difficult. In my experience people are far more likely to employ you if they either know you or if you have been recommended by people whose opinion they value. In other words, writing endless letters and sending off endless demo CDs can often be expensive as well as fruitless. Instead, try to capitalise on contacts you have a personal link with, ie friends of friends, people you meet in a casual setting, such as parties.

One thing I learnt very quickly when starting out was that I really needed my own music studio. This is essential for two reasons, the first being that it saves you a lot of money in the long run and the second being that you will often have to work long and antisocial hours. A sound engineer may not be as inclined as you to work through the night and sleep on the studio floor, so get yourself a studio (with SMPTE synchronisation to link your music to video) and buy yourself some independence.

At college I had a very good piece of advice from a visiting lecturer, which I have often thought of in the years since I left. It came from Howard Goodall who is a very successful composer in the UK and USA. He said that it took him seven years to get to a stage where he was supporting himself entirely by composition work. He urged us to be as versatile as possible with our music, to earn a living, ie by teaching and performing as well. Essentially what he was saying was, 'be patient'. Don't expect success immediately. You might be lucky and start getting lots of work straight away but for most people it can take several years to build up contacts. Don't give up, and your patience will be rewarded.

Case Study:
Charles David Denler – Filmscore Composer
LittleRiverMusic

Films: *One Life In A Desert Sea*
20 Years With The Dolphins
Miracle In The Pacific

Time For The Music
Writing music for wildlife films without going broke

The producer has just spent the last few years of his life on a masterpiece. The rough cut is ready, and enough strength has been mustered to approach the distribution giants. But wait, something is missing. Under the dull roar of grant proposals, edit floors, and countless hours of research, someone begins to hear the music. Every last dime has been spent on footage, and now the producer needs to work out a music budget. There is always library music. The plus is that it is cheap. But how many other films and commercials will contain the same library cuts? Nothing can compare to having a score fully composed and thematically tailored to film. Music is the frame that will surround the masterpiece. How would the Mona Lisa look if da Vinci had shopped for his frames at Wal-Mart? Wildlife films are incredibly rewarding to work on. The footage is usually inspiring, but the budgets often leave something to be desired. Original music can be expensive, but here are a few suggestions to help tame some of those costs, and keep things legal.

I am sure most composers have had this phone call at one time or another:

"Hi there. Thank you for your demo CD, great stuff! If it's all right with you, we have cut our film to some of the music on your demo. Do you have anything else you can send us?" The problem in this scenario is that the music on most demos has already been used in another film. This means that it falls under the ownership of the company that now retains the film rights. This could mean big trouble down the road from a legal standpoint. The way to avoid this, of course, is to ask the composer up front about rights to the music. He or she will usually tell you that the music is already owned but will gladly compose a similar theme for you. Now the producer is back to an original music score, but how can he or she afford a fully composed soundtrack?

One way to keep costs under control is through up-front music-licensing negotiations. Keeping composer's rights to the national and international royalties generated by the film is a great trade-off. In the long run this will generate future income, and in the short term the producer may benefit by having lower initial music costs. Have you ever wanted to release a music soundtrack with a film? (This is an honor not just reserved for feature films!) Many composers, including myself, have negotiated with documentary producers for soundtrack rights. The benefit to the producer is lower up-front costs. Not only is this a plus for the musician's ever-growing discography, but the film also gets free exposure! Another wallet-saver is to work out an initial price for the spec film and a buy-out price for the final score. Now the composer has a chance to invest in the producer's dream as well, without going broke in the process.

What about the pilot? Most musicians will score a pilot for free as long as there is some type of pay off agreement. The agreement might read something like this: *The composer agrees to a pilot fee of $_____ payable upon completion of the film. This fee may be used as a credit towards the final music score or as a buy-out for the pilot music.* This type of agreement allows the producer to use a different composer on the final score if needed, but also ensures that the pilot composer gets paid for his or her contribution.

Remember, keep it affordable and legal, but most of all, keep it memorable!

Dubbing Mixer

The dubbing mixer comes in at the post-production stage to mix all the sounds together and produce the final sound-track. This job is occasionally done by the picture editor while cutting the footage together, but the best results are usually when a sound specialist does the actual mixing of the tracks the editor has laid. This process is often called sound design.

The live sound, extra location sound (atmospheres etc), music, narration and sound effects will all be separate recordings that have to be blended together seamlessly and creatively in the studio. In addition the dubbing

mixer will have to edit out all the unwanted clicks, buzzes, camera operator's expletives etc from the recorded tracks. This is a highly creative process that requires a lot of experience. He/she is also responsible for ensuring the sound is accurately in sync with the images.

The dubbing mixer may also be involved in the studio recording of some of the sound – the narration and 'Foley' sound for example. Foley sounds are all those little scuffles, crunches, splashes, animal footsteps etc that couldn't be recorded for real (usually because they are very quiet or too far from the microphone at the time). In fact in many films there is far more Foley sound than the viewer appreciates. The sounds are created by splashing water in a bowl, walking on a tray full of sand or leaves and twigs, chopping cabbages in half, chewing celery sticks and so on. This is usually performed by the dubbing mixer or assistant, or a specialist Foley artist, or any passing member of the production team who is a bit peckish!

Qualities required: excellent knowledge of sound engineering and recording techniques and equipment; ingenuity; a good ear for mixing and blending sounds; ability to interpret the overall feel of the film and creatively produce the appropriate sound track.

Picture Editor

The picture editor's job is very important and highly creative. He/she is responsible for expressing the director's narrative structure of the film – taking all the footage, cutting it up, choosing which bits to include or reject, and what order to put them in. They will also apply any post-production special effects to the images (eg slowing/blurring footage) to enhance the production.

So the editor has to be a great story-teller and have a thorough understanding of the subject and the techniques at their disposal. There may be hundreds of hours of footage to sift through before choosing which sequences to include, requiring a systematic approach and a great memory.

The picture editor may work alone, or more usually at least with the producer/director, and possibly together with the dubbing mixer. Not so long ago all editors worked by physically cutting strips of film into sections and arranging them in a linear sequence. These days the editor is likely to be sitting in front of a computer editing system such as Avid.

The first stage is to 'digitise' the footage into the hard drive of the computer, and then to view it and cut and paste it around until the desired sequence is reached. For a big film this can take weeks, requiring a lot of persistence. Once completed, a master will be made of the final cut, and this will be used for copies/broadcast etc. Major projects may have a number of picture editors overseen by a supervising editor. A series may have a series editor who oversees the editing of each programme to ensure it is in keeping with

the feel of the series.

Qualities required: good memory; some knowledge of natural history; story-telling skills; ability to express the producer's wishes creatively with the available footage; experience of the associated technologies.

Case Study:
Rob Harrington – Editor / Supervising Editor / Composer
Redeeming Features International

Films: *A Little Fish In Deep Water* (Deeble/Stone for Survival)
Maneater! (Cicada Films / Animal Planet)
The Great Dance (Craig & Damon Foster for Off the Fence)

I may be the exception (without being exceptional) when it comes to working in wildlife – my background is a broad base of film-making: features, dramas, news, current affairs, documentaries, anything that comes to me as a freelance picture editor.

I had the classic beginning: a tea-boy in a small company in London, in the days when there was still a structure of apprenticeship training. If you were, say, a third assistant on a feature you knew that the 'second' would look after you and tell you what to do. After a year you would be a second assistant editor and, after a few years, a first! This training meant that there was nothing that they could throw at you that you couldn't handle

Until I had my ten years at Survival (the longest-running and most-successful wildlife film company in the world, for those with short memories) I had never cut a wildlife film. All that I had learnt about editing was just as relevant though – if I wanted to know anything about the animals there was always an expert to consult, often the writer/producer. Three people essentially made a film: the cameraperson, the writer/producer and the picture editor. The editing starts when you look at the rushes.

It is often said that a editor's skill is an invisible one. We do not bear the responsibility of having to react in real-time to live events and so have the freedom to filter, assemble and manipulate what is given to us. The manipulation is one of evoking an equivalent of the reality that happened. An editor is a director in the cutting room.

A bird may have been filmed flying only on to a nest, but the story asks for the bird to fly off. A reverse action slo-mo followed by a double speed jump cut may achieve the desired effect. This is a detail and getting the cuts to work is a vital, but only a small, part of an editor's daily task. The overall structure of the story is paramount; sometimes the desired story doesn't get filmed and you have to construct another one out of the existing material.

The method of working varies according to the person you work with: some producers are very hands-on and want you to be merely a skilful machine-operator and, at the other extreme, some will just leave you with the material and let you get on with it until the story emerges. If you are fortunate it will be a true partnership of discovery, but the understanding of the originator's personality always forms the approach. To know the kind of thing that may surprise and please your fellow film-maker can be a real joy.

If the film is not one of pure animal behaviour then it may demonstrate that filming humans requires a different skill from filming animals and that a background in the wider world of film-making will be an advantage. Being aware, as an editor, of all the dramatic devices, and where they may be used most successfully, (whether it be the sound effects, script writing or music) will help create a cohesive structure with satisfying emotional content.

I enjoy making films as much now as I did when I started. If a young hopeful can show their passion and commitment to films and attract a certain amount of luck, then it is possible, even now, to have a career in wildlife film-making.

Distributor

Essentially the role of the distributor is to take a film and find markets for it. This does not just mean finding a broadcaster – it may also involve home video sales, DVDs, CD-ROMs and other products. Films can also be broadcast in many different countries and be repackaged ('versioned') in different ways and in different languages.

Increasingly distributors are not just acquiring (ie signing distribution contracts with) completed films, but are getting more involved in the production side. Once distributors have a relationship with broadcasters and other markets, they get to know what is required and will be more likely to provide this if they can steer the production in that direction from the start. That's why you will quite often see the name of a distributor as an executive producer.

Most independent producers will want to know where their film will end up before they start spending money on it, and so will be seeking a distribution deal early on. The distributor will then guide the producer, perhaps even supplying staff, to ensure the result can feed the available markets.

Being a distributor needs good experience of the film industry and markets, so this is not a job you would expect to get early on in your career. Some distributors move into this field from production, and others come from other aspects of the film industry.

Qualities required: good salesmanship; a good understanding of how films are produced; knowledge of markets for films; negotiating skills; ability to interpret and foresee the needs of broadcasters.

Case Study:
Simon Willock – Head of Factual (Distributor/Producer) Southern Star

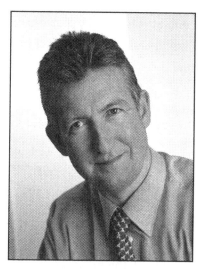

My first job in television started on 5 April 1976 with a small independent distribution company. I have therefore been around for some time! Over the last 2 ½ decades I have seen the industry metamorphose from a rather safe 'club' of Public Service Monopolies around the world, serviced by a small group of independent distributors and producers, to the rather dangerous and massively fragmented market-place we now find ourselves in!

For most of my career I have been a jack-of-all-trades dealing with all genres of programme types. For the best part of the nineties I was MD of the distribution company of a large British production/distribution group – Primetime Television. During my seventeen years with Primetime I cut my teeth on as diverse a range of programming as is possible to imagine! The range included being Executive Producer for ten recordings from the Bolshoi Ballet to being the pioneer of Australian soap opera. Interspersed in all this career 'experimentation' there has always been a love for and commitment to factual programming and, in particular, wildlife and natural history. But then a degree in zoology and geology gave me more than a passing interest in the natural world. Not to mention my father (Colin Willock) who was the founder and creative force behind the Survival Series, and for thirty years was pretty influential on my tastes in television.

As Head of Factual for Southern Star, I now oversee both the production and the commissioning of factual programming worldwide. About fifty percent of this is wildlife programmes, the rest being made up of history, archaeology, science and travel and adventure. This also includes the running of Oxford

Scientific Films (the documentary production unit of the company's UK division Southern Star Circle), and sourcing product for Southern Star Wild & Real (the 2000 hour catalogue of wildlife and documentary programmes available through Southern Star Sales).

SS Factual consistently increases its catalogue by between 50 and 70 hours of documentary programming annually. I work with a wide range of producers (in-house and independent) to identify and craft documentary programming for a global audience, and to manage and effect co-productions, pre-sales and investment in order to complete funding. SS Factual is now regarded as one of the principal players in factual and wildlife programming.

A degree of nepotism must be credited for my arrival in the business. In those days it was something of a family business and whom you knew counted. These days it is about how good you are! If survival is a measure for success then, twenty-six years and 'not out' at least means that I have managed to stay ahead of the pack! Just.

This is a business that thrives on ideas and passion but sadly – as my own metamorphosis from distributor to producer has told me – distribution and production are now inextricably linked. Broadcasters, themselves strapped for cash, rarely fully fund programmes any more. Film-makers have to think commercially and be prepared to make creative compromises if they want to make television programmes. Commerce and art make uneasy bed-fellows, but an understanding of the needs of foreign broadcasters as well as domestic ones is vital. In order to pay for the cost of a wildlife show the producer now must craft it for a global audience.

Broadcaster/Commissioning Editor

This role is worth a mention to complete the picture! The broadcasters are the big companies who buy rights to broadcast films from the producers or distributors. The films are then transmitted to television aerials, satellite or cable.

Some broadcasters service only a certain country, or region, and are unlikely to specialise in wildlife films. Only the big players such as National Geographic and Discovery can do this. They don't just broadcast wildlife programmes – Discovery for example also specialises in travel and adventure, civilisation and so on, but with channels like Animal Planet, wildlife films are very important to them.

The commissioning editors are the all-important people who decide which films will be broadcast. They will either buy the rights to an already-completed film, or, like some distributors, be involved in the production and style development of the film. They don't just see what films are around, but actively seek programme ideas. They have strict budgets and timescales.

Commissioning editors need to be in touch with what the viewing public wants, and keep abreast of ratings figures and what other channels are doing, predict future trends etc. They are typically inundated by pitches, and a good deal of their time is spent sifting through film proposals looking for ideas that will be right for their network.

Like distributors this is a senior position that you will arrive at only after much experience of the industry.

Qualities required: thorough knowledge of the television industry; knowledge of production techniques and latest technologies; ability to analyse what the public wants and predict future trends.

Location Manager

Sending film-crews on location overseas can be fraught with difficulties and unexpected complications. The producer's best friend in these situations will be the location manager who has a thorough understanding of the needs of a film-crew, and also of the peculiarities of working in a certain part of the world.

The location manager will have to have good experience of, and probably live in, a region popular with film-crews. They will certainly need to be on hand when the film-crew is there, and to make a vague living out of location managing they will need to deal with quite a few productions! This probably means working in an area teeming with wildlife, but the obvious locations have had many films made about them, and already have enough location managers – so the key is to find a new area and entice film crews there.

Location managers will be working with the producer (probably long-distance) in the planning stages to organise filming permits, licences, permissions, government liaison, scouting, local research etc. Before the crew arrive the location manager will organise transport, customs issues, accommodation, equipment hire and so on. While the crew is actually filming on location there may be further requirements to co-ordinate such as porters, drivers, cooks, shipping films/tapes, equipment repair/replacement, assisting with crew accidents and illness. It's often a case of expecting the unexpected!

Qualities required: excellent local knowledge of a particular region – both the wildlife and the regulations; ability to speak a number of languages; ability to deal with government officials and handle all manner of administrative hurdles; problem-solving expertise!

Case Study:
Jean Hartley – Location Manager
Viewfinders Ltd

I got into the wildlife film-making business by accident. I was organising a bird watching marathon to raise funds for a children's hospital, and BBC producer Adrian Warren heard about the event and thought it might make a nice half-hour programme. After the event, which involved organising seven teams of birders and two film crews, Adrian told me that he would be coming back to Kenya to work on a series called *The Great Rift*. He asked if he could call me if he ever needed a hand – of course I agreed.

The Great Rift took two years to film, with crews covering Kenya, Tanzania, Ethiopia, Rwanda, Djibouti and Madagascar. During this time I was doing people's accounts on a freelance basis, so was able to juggle my time if called upon to help the BBC. I drove out into the Rift Valley to check on a Verreaux's Eagle nest and transported 88 gallons of aviation fuel in my truck to the Tanzanian border to refuel a helicopter. I flew in a single-engined Cessna over the flamingo nesting colony on Lake Natron in Tanzania to assess the number of breeding pairs and the age of any chicks, towed a Parafan on a trailer from the airport, and housed this extraordinary flying machine in my driveway for several months. A regular stream of BBC people came and went, often staying in my tiny rented house.

In July 1988 the last crew passed through to Tanzania, and I realised that it had all been great fun – something that is hard to experience when battling with balance sheets; and depreciation. I felt that there was a niche to be filled, that I could set up a business dealing exclusively with wildlife film-makers. I felt that they would find working in East Africa much easier if there was someone based here to work with them who knew their way around – someone sympathetic to wildlife, who spoke the language and could deal with the bureaucratic process of getting all the paperwork in order – who could go out and check whether the birds (or wild dogs or elephants or lions or termites) were breeding (or hatching or fledging or migrating). I felt that I had the right experience: born and bred in Kenya, fairly fluent in Kiswahili, extremely interested in all natural history – particularly birds – and a proven organiser. So, I set up a company – ViewFinders Ltd – in partnership with a girlfriend of similar background, interests and ability.

In my two years of working on *The Great Rift* I had learned that a wildlife film festival was held in Bristol every two years. Here, I was told, several

hundred wildlife film-makers gathered under one roof for a week, making it the best place to meet everyone else in the business. This, I felt, was the place to launch the activities of the new company, so I registered as a delegate for the Wildscreen festival to be held in October 1988. In the course of that week, I met two producers who needed assistance, and they became our first clients. On my return to Nairobi, another team made contact – National Geographic, who were trying to set up a project featuring Jane Goodall in Burundi and Tanzania, and who had been referred to us by one of the BBC Great Rift team. We thought subconsciously that we would make our name on home ground before branching further afield in the region, yet only one of our first three clients wanted to work in Kenya. Nothing goes quite to plan ... but ViewFinders officially started working in January 1989 – we were off the ground.

Since then many hundreds of film crews have come through our doors, and we have become the established documentary 'fixers' for East Africa. We have worked in every format from stills to Hi-8, 16mm, 35mm, HD, various sorts of video, and 70mm (IMAX). Film subjects have included insects, birds, mammals, reptiles, plants, athletes, conservation, sport, prehistory, science, tourism, adventure and travel, news, politics, fashion, religion and cookery. Clients have come from over thirty countries, and we have been responsible for them in Kenya, Uganda, Tanzania and Zanzibar, Rwanda, Burundi, Egypt, Sudan, Somalia, Ethiopia, Djibouti and both Congos.

In this time, in addition to all the paperwork involved such as licences, permits and permissions, we have shifted many tons of equipment through airports, loaded aeroplanes and vehicles of all shapes and sizes, and spent hours in hospitals with ailing crew members. We never take 'no' for an answer, and the word 'impossible' is not in our vocabulary. Stuffed lions from China to the Serengeti? Cases of wine to the Maasai Mara? Birthday flowers to the director's wife in Australia? Giraffes to Uganda? An artificial elephant trunk to South Africa? Life-sized carved wooden hippos to Canada? Turkeys for Thanksgiving to Gombe Stream? A hot air balloon to Rwanda?

In the mists of memory, several film projects stand out. We remember with particular affection the following (no offence intended against those not listed):
IMAX: *Mountain Gorillas*
BBC: *The Great Rift*
Ultimate Guides: Big Cats

Questions for newcomers: Do you know your home ground really well? Do you know its wildlife, and where to find it? Do you speak the local language, and know your way around various government departments? Are you a good organiser, with a logical mind? Are you efficient at keeping track of other people's money? Can you handle more than one thing at a time? Do you have an encyclopaedic memory? Are you good with people? Most importantly, do you have a sense of humour? This is a demanding job that involves long hours of work and very few weekends or holidays. You will not get rich, but you will make a lot of friends.

Case Study:

Karen Brooks – Producer, researcher, facilitator, location manager Facilitation Southern Africa

Films: *Champions of the Wild – Wild Dogs*
World Gone Wild (series)
State of the Planet

This is the fifteenth year I've been in the television industry in Johannesburg, South Africa. I've worked on enormous projects – the live international broadcasts of two Miss World Pageants at Sun City – and tiny ones – a five minute children's cooking series. From the best of the bunch – blue-chip documentaries such as the BBC NHU's *State of the Planet* – to the ones I'd rather forget – an in-house safety series for a steel company.

The advantage of working in such a small industry is that I learn something on every single production. I try to keep up with the technology, I can supervise an edit and run a VHS offline suite, I will research any subject from aerospace to zoology, I script for live shows and voiceovers, I'm great at casting and have even done a bit of wardrobe and make-up. So when I deal with clients I know the process they have to go through.

So how did I make the transition from beauty pageants (et al) to wildlife? Early in 1997 I was fortunate to work as South African production manager on Bertram van Munster's *Wild Things*, a segment show for Paramount Syndication. Initially I thought it would just be the usual – here's the budget, these are the stories, organise a crew and make it happen. But when I left the project over a year later I had discovered a passion, and learned so much about wildlife in South Africa, Namibia, Botswana, Zimbabwe and even Malawi and Swaziland that I could have written a book myself. I figured out how best to get permits, send crews and equipment in and out of those countries where the rules seems to change constantly and yesterday's best friend is suddenly *persona non grata*. I had also discovered a gift for working with foreigners – even though we all speak English, our cultures are so different. Embracing those differences is what makes this work exciting and challenging.

I got my lucky break when a couple of the people who moved on from Wild Things called me to assist on their later projects. I broke into the US market with, among others, *Wildlife Legacy* for Turner and *World Gone Wild*, also a segment show, for the Fox Family Network. At the same time I have to mention my friend and mentor, Jean Hartley of Viewfinders in Nairobi, who

took a leap of faith and recommended me to her long-time clients at the BBC Natural History Unit and other production houses in Bristol. I still rely mostly on Jean's recommendations and word of mouth in Bristol and Los Angeles for my business. I also have my own simple website and do a small amount of paid or reciprocal advertising (it's worth mentioning www.Mandy.com and of course www.wildlife-film.com).

And what do I actually do? Well sometimes it is as little as meeting a cameraman in international arrivals at Johannesburg Airport, dragging him and his three trolleys of equipment less than 500 metres to domestic departures, helping him check in for the next flight, having a beer with him and wishing him a good trip.

Sometimes it is as much as being given a concept – Hollywood herpetologist on safari in South Africa and Madagascar – and researching an entire shoot, suggesting locations and story subjects, building a schedule, getting permits, hiring additional crew, and going along for the ride. Even though I haven't seen the programmes, *Jules Sylvester's Wild Adventures*, due on Discovery any day now, is my favourite shoot so far. That has a lot to do with standing in the Madagascan rain forest listening to indries call, and weeping at the sheer beauty of it all. Not to mention getting to see my beloved elephants (and cheetah and mongoose and lemurs and more) in the wild.

Since starting Facilitation Southern Africa in mid-1998 I have worked on all sorts of productions – blue-chip and mass market, seriously scientific or obviously 'in your face'. Favourites include *Champions of the Wild – Wild Dogs*, a simply beautiful film by Omni Productions in Canada; the entire *World Gone Wild* series – great crew, cast and fabulous memories; and of course *State of the Planet*, a very significant series on which I made some great friends. Apart from wildlife films, I've assisted on a foreign office film about the English language; a History Channel film on Gold; "early man" documentaries for UK and German producers; recreations of holiday horror stories for BBC Features (complete with trained elephants and a fibreglass hippopotamus); an interview with Nelson Mandela for a Japanese network through an Austrian producer; and an Australian production about the Anglo-Boer War.

Now for the heavy stuff. Firstly, the wildlife film-making industry has changed dramatically and the demand for fixers has dropped. If you want to do this work in South Africa, be prepared to supplement your income with other jobs. I still work on local productions and anyway I need my "fix" of live television from time to time.

As a facilitator, you clearly need to be skilled at production – budgeting, scheduling, hiring, negotiating, resourcefulness, achieving the impossible – most of which come from experience and are hard to teach. But because you are constantly working with clients who are passionate about their films, you have to go the extra mile.

Be upbeat, friendly and helpful – on days when I'm not feeling that way I

keep a low profile. Remain flexible and open to learning at all times – I don't know everything, I do make mistakes and I admit to both constantly. Diplomacy is your best ally – bite your tongue if your recommendations are ignored or laughed at – after all, it's not your film! Finally, be honest and trustworthy every second of the day – it's someone else's money you're dealing with, and as they say, you're only as good as your last production!

Stock Footage Library Manager

Wildlife film-makers, whether large companies or individual independents, will gradually amass large collections of footage which can be sold to other producers as an additional revenue stream. Where large producers are concerned this can mean dealing with thousands of hours of footage.

Some stock footage libraries will specialise in certain subjects such as underwater wildlife, or will specialise in the wildlife of a particular region such as the Antarctic or India.

One of the aims is to sell sequences to other producers for their productions. For example a film about tigers may be missing an all-important mating scene – if the camera crew have already spent a fruitless year in the jungle then the easiest option is just to purchase this scene from a library and weave it into the film. There are other outlets for footage, though, such as commercials, educational CD-ROMs, websites, presentations and so on.

The library manager will have the task of liaising with customers and locating the footage they require. They will also be responsible for adding new footage to the library and cataloguing it accordingly. They will control the viewing of footage by potential customers either in the studio or over the Internet, and on purchase will negotiate the rights/licenses and fees.

Qualities required: good memory; logical and systematic working methods; knowledge of database and cataloguing techniques; negotiating skills; some knowledge of natural history.

Case Study:
Rosi Crane – Library Manager
Natural History New Zealand Stockshot Footage Library

What do I do? I sometimes wonder myself at the end of a day spent watching TV, reading magazines, talking to people, writing emails – a cushy kinda life uh? Actually, more formally, all the above revolve around knowledge and information.

My remit is to exploit the NHNZ collections commercially. The library has clients, both external and internal. The only difference between them is that we don't charge internal clients.

Dealing with clients means being a sales person, with all the hype and hustle that may or may not entail. This is tempered with a good deal of circumspection and balance – you can't afford to put your precious clients off. But above all dealing with clients assumes a deep knowledge of the material in the library. Knowing that what the client asks for when they first contact you is possibly only half their requirements; knowing animal behaviour and world geography sufficiently to be able to offer alternatives; knowing the footage you have, how it can be used, whether there are any rights encumbrances (actually more exactly – knowing which clips are subject to restrictions and being able to find out what those entail); knowing enough technical details about how films are put together to help the client through their post-production maze (many clients are new to the game and need a lot of patient explanation – oh why is film research given to people with limited experience?); knowing the kinds of deals that can be struck, negotiating the best win wins for client and library.

So where does all this knowledge come from? For me it was a degree in geology, a spell working in WH Smith, a spell working in a polytechnic library, then a Master's degree in Information Science. This is where I learnt the principles of what has subsequently been called data mining, knowledge management, intelligence gathering, database management and all the other buzz words that basically mean knowing how to catalogue, index and retrieve information.

And the knowledge also comes from experience! Mine includes umpteen years at BBC NHU, and nearly umpteen at NHNZ!

Working in a library requires someone with a demonstrable eye for detail and some semblance of empathy with images. These days when recruiting staff I test their abilities with a short proof-correction exercise and ask them to "have a go" at picture description and indexing – the results can be very illuminating! To me formal qualifications are less important than a practical, pragmatic interest in information handling – which of course includes labelling! Knowledge of the industry and how to deal with footage clients is generally learnt 'on the job'. I have employed all kinds of people and many have become editors, camera, researchers, producers, where basic organisational skills learnt in the library have doubtless contributed to their success.

Let this show that generally speaking librarians working in this industry are not the run-of-the-mill book-ish sort – the mainstay of the public library system that everyone will be familiar with since first learning to read. Oh no! We are able to deal with creative temperaments and robust personalities – indeed we may even fit in those categories ourselves! We are not so much librarians as Creative Intelligent Agents!

Multimedia Producer

As already mentioned, television broadcast isn't the only final destination for wildlife films. Increasingly they are used in CD-ROMs, DVDs, websites and other multimedia applications.

One aspect of multimedia production is the actual authoring of products such as websites and CD-ROMs. This could involve converting existing wildlife films to CD-ROM or DVD, or creating custom-built interactive CD-ROMs for a variety of applications including education, tourism, promotions etc. This may mean collating a vast number of assets such as video, still photographs, text, animations, sound, music, narration etc, and creatively programming these together.

As the interactivity of satellite/cable television and the worldwide web converge, there will be increasing need for multimedia producers skilled in interactive design. As the technology improves at speed so does the desire for streaming media (the process by which moving images can be transmitted via the Internet.)

Multimedia producers will spend much of their working lives hunched in front of a computer – but this is becoming increasingly true for many jobs.

Qualities required: a thorough understanding of computer and digital technologies and the workings of the Internet; ability and desire to keep up with rapid developments; a good grasp of the possibilities of interactivity; creative flair; project management skills; a good eye for graphic design.

Case Study:
Alastair Lawson – Producer of interactive wildlife CD-ROMs
Alastair Lawson Productions (ALP)

Films: *Cry for Africa* (importance of conservation in Botswana)
Into Africa (Documentary on the beauty of the Okavango Delta, Botswana)
Mashatu (Documentary about Mashatu Game Reserve, Botswana)

CD-ROMs: *MalaMala Game Reserve* – South Africa
Tswalu – Kalahari Reserve – South Africa

African Wildlife Collection (collection of award-winning wildlife photographs)

Interactive Multimedia in Wildlife Film-making

Wildlife film-making will always require dedication, patience and a keen knowledge of your subject. New Age film-makers, however, can benefit enormously from understanding the requirements of new technology.

New technology, such as DV cameras, longer battery-life, improved optics and a wide variety of accessories, will make a wildlife cameraman's job only easier. As a wildlife cameraman you must still rely on a large dose of luck, anticipate your subject's next move and have a good eye for composition and story-telling. You will not necessarily be a better wildlife cameraman by having the best and latest shooting equipment on the market. You will, however, be a better wildlife producer if you understand today's technology.

I have been shooting wildlife for many years and about seven years ago took a huge step into the techno world – not so much with my shooting style or methods, but with the end product. Now, all my work is post-produced for the hungry cyber-world and DVD home theatre market.

My career started as a stills photographer, developing my skills for composition and lighting. I then moved into feature films, developing further skills in movement, story-telling and editing techniques. Eventually I started my own production company shooting corporate videos that taught me about budgets, production planning and sales. Eventually my situation allowed me to produce the productions of my choice and, as wildlife is my first passion, I used my developed skills to produce wildlife films.

To develop stronger 'bush' skills I freelanced as a wildlife tour guide/ranger, giving me the opportunity to spend many months at a time in the African bush.

As mentioned, technology is helping us shoot with greater ease but the fundamental skills required to be a good wildlife cameraman remain the same. Things really change only when you're ready for the edit. Advancing technology gives you a multitude of options and formats with which to deliver your finished product to a variety of audiences.

The old school of wildlife film-makers relied on their trusty 16mm film cameras, and would edit either on a 16mm table or opt for a video edit; but ultimately they would end up with a master video tape for broadcast by TV

stations, networks and video rentals.

Today the picture is very different. Once you have your finished footage you have the option to deliver your project to video tape, DVD, CD-ROM or the Internet. Your audience now includes DVD home theatre viewers, information kiosks, school education on CD-ROM, marketing CD-ROMS and Internet users.

Some will say that you should just shoot and edit your movie and it can be transferred to all other possible formats – not so simple! Firstly, if your target format is DVD or CD-ROM should you shoot for standard TV aspect ratio or the new wide-screen 16 x 9 ratio? Your edit should consist of 'chapters'. DVD and CD-ROM allow the viewer to skip from one 'chapter' or section, to the next. Alternately, the movie will be menu-driven and allow the viewer to choose a topic for further information.

For example, a typical CD-ROM that I produce may consist of only 60% wildlife video material, and the rest of the CD would contain photographs, text, animation, sound and hyperlinks to the Internet for further information.

When I shoot wildlife for a CD-ROM my video is storyboarded into sections before I begin shooting. I also determine what photographs are required and a shot list is also drawn up beforehand. I also need to gather text information to be included on the CD. My wildlife film is thus no longer a film or a full story, but rather a collection of smaller clips that go towards painting the bigger picture.

So, in brief, when I take on a project I need to wear many hats. I go out to shoot video as a wildlife cameraman, I then put on my photographer's hat to obtain stills and finally I wear my author's hat to gather text information. Once the shoot is complete, I enter the editing phase. Here we edit each 'chapter' into its own stand-alone little movie, often averaging about three minutes in length, although this depends on the particular requirements.

When all the editing is complete, we enter the authoring phase. 'Authoring' is the term used for building the computer programme that links everything together. At the same time design- and content-gathering takes place. Here we design the look and feel for every page or screen of the project. The text is then professionally edited and checked for accuracy, audio is recorded and edited into the authored programme and video clips are compressed and inserted.

Theoretically the project is now complete. This finished master can now be cut into DVD, VCD and CD-ROM format for duplication and distribution. Should any of the video be required for the Internet, the shorter clips are easily compressed into the correct format for downloading or streaming. If the information is to be used for web sites, the individual video, text and photographs can easily be converted to web-friendly file types.

If you're intending to produce your own programmes, be aware of some of

the new markets that are opening up for retail or distribution. Many of my regular projects are developed for particular clients, usually the owners of up-market game reserves who require interactive CD-ROMs to market the game reserve facilities and attractions to visiting tourists and travel agents. In some cases, we develop DVD or CD-ROM for sale in retail outlets as a souvenir for tourists to take home.

Another new trend that is opening up to the wildlife film-maker is that of the interactive 'coffee table book'. We can now get our work sold in bookshops, as multimedia information on a particular subject or animal species.

The new markets are growing every day and, I believe, will continue to grow. As technology expands and enters the acceptable mainstream norm it is up to us as wildlife producers to feed the market and introduce new ideas and methods of distribution of our work.

The best advice that I can offer to aspiring wildlife film-makers is that if you have a passion to spend your days out in the elements of nature waiting for that special and unique moment – take the time to enjoy and admire it – but spend your free time wisely by learning and understanding how the public are using technology to view wildlife information.

Sooner or later you will be asked to shoot footage for the Internet, DVD or CD-ROM, so be prepared and understand the request.

The technology is still new and few rules apply, so be a trend-setter and set new standards.

How to Get Started

You will have seen from the case studies in the previous chapter that there are many different routes into the wildlife film-making industry – and many of these have involved luck and chance. There is no set path that will guarantee you success, but there are definitely a number of things you can do to prepare yourself for the best chance.

Let's start by looking at a few general ways you can prepare yourself, whatever job in wildlife film you are looking for:

1. Learn about Natural History

This should come naturally to you! If you are not passionate about natural history in the first place perhaps you will be better-off pursuing a career in another area of film/TV that will be easier to get into and better paid!

Learn about natural history by studying (see next chapter *Education and Training* for more on this) by reading, by watching TV and through first-hand experience in the field. A good knowledge of wildlife throughout the world is highly desirable (but not essential as you always research your topic), along with a good grasp of world geography. Although there may be specific aspects of natural history you specialise in, you can't guarantee work in your particular field of interest, so a wide general knowledge can only be a good thing.

Your learning about natural history should include animal behaviour, and much of this will come from watching wildlife films, and from nature itself. Spend time in the field watching wildlife for long periods, make notes, understand what the animals are doing, start to learn fieldcraft so that you can watch animals without being seen, heard or smelt. Get yourself a good pair of binoculars. Practise tracking animals, building hides, pretend you are making a film and make notes of shots you could have taken or sequences you would like. This is useful whether you want to be a camera operator, or a producer, writer, picture editor and so on.

Read books on natural history, and magazines such as BBC Wildlife Magazine. Study atlases and test yourself on where in the world various creatures (and plants) come from. Strive for expertise – never stop learning.

2. Watch TV

It may sound like an obvious thing to do, but I am amazed at the number of people I talk to (both wannabes and those already in the industry) who

haven't seen, or maybe haven't even heard of, certain landmark programmes or series. So, watch as much wildlife TV as you can. Subscribe to satellite or cable TV if available and regularly tune into channels such as Discovery Animal Planet and National Geographic as well as any wildlife programmes on your regular national channels. And don't tell me you can't afford satellite/cable – if you badly want to make wildlife films it's a priority.

When you are watching wildlife programmes it is useful to video them so that you can go over certain points later. For each film make notes on all the credits and remember who it was produced by. Get to know the names of personnel connected with various companies/productions. Pretend you are a judge at a wildlife film festival and analyse each film carefully. Not all that you see will be good! Give the film a score for various aspects such as photography, sound, editing, script, narration, animal behaviour, educational value, scientific content, music and so on. Build up files of notes on films you have seen for future reference. This may sound like a lot of hard work, but it is free (!) and a very valuable way of learning the art, and understanding the elements that go to make a good film.

It will also help you develop your own style – what type of programmes 'work' for you, how could you improve on what has been done before, what would you have changed if you had been the producer/writer/editor etc? At the same time be conscious of changing trends – what sort of films are being shown at the time, what doesn't work anymore, what styles are favoured by different channels. All this will help you build up a picture of the industry. Again – making notes on channels/styles etc will help you remember the information and will form a useful reference for future research.

Make a special effort to see films that win awards at the wildlife film festivals. You can find lists of the most recent winners at each festival's website. Find out when the films are airing from the producers, or buy them on video, or you can view them in video booths at the festivals. Think about why they have won the awards they have – do you agree with the judges?

3. Get informed

The more you know about the industry the better – so:

• Subscribe to and read the e-zine Wildlife Film News every month (it's free!).
• Regularly check out www.wildlife-film.com – explore the directories to see who does what.
• Surf the Internet – find out more about production companies from their own websites.
• Read trade publications such as RealScreen magazine.
• Join as many relevant organisations as you can – such as The International Association of Wildlife Film-Makers, Future Crewing, Filmmakers for Conservation, and again – don't tell me you can't afford it – if you're serious it is a small price to pay for information and contacts that may prove vital to your success.

Further information about all of the above can be found in the chapter *Organisations, Projects and Further Information.*

4. Develop skills

First of all there are a number of skills that will be useful to you whatever job you want to do.

Computer skills are needed across the board these days – so make sure you are completely happy with the basic necessities such as emailing, surfing the Internet, word processing (especially using Microsoft Word), and generally using PCs (even if you are an Apple Mac die-hard you have to face the fact that the vast majority of people use PCs!). Strive to ensure your typing is up to speed – you don't need to be a 100 word-a-minute touch typist, but it is painful to watch somebody typing up a shooting list with occasional jabs of one finger while constantly searching the keyboard for the 'm'!

Other skills such as image manipulation (eg using Adobe Photoshop), desktop publishing (eg Quark Express), video editing (eg Adobe Premier), website editing (eg Macromedia Dreamweaver), interactive programming (eg Macromedia Director) will be a bonus, and may even make the difference between you getting a job or not. Develop your computer skills through courses, teach-yourself books, watching someone already skilled, and lots of practice.

Communication skills are also essential whatever you do. This may sound obvious yet I have employed people in the past who were highly skilled at specific jobs yet unable to communicate adequately. I had to let go an incredibly talented database programmer recently because he simply couldn't make himself understood on the phone! You need to be able to speak clearly and confidently, giving the right amount of information at the right pace and in the right tone. You need to be able to do this on the phone, face to face, and to a group of people. You also need to be able to communicate effectively in writing – by email and letter. If you feel unsure about any of these skills they can be improved by short courses in communication and by lots of practice!

Financial skills will certainly be important if you are a producer in charge of the film budget, but will also be crucial if you are to be self-employed. You can take short courses in basic accounting and book-keeping, or study from teach-yourself books. Practice using spreadsheets on your computer (eg Microsoft Excel).

Then there are all the skills to develop that may be more closely allied to the job you are aiming for. You will benefit from the following skills whatever job you are aiming for, as I keep mentioning, the more you know about the entire process the better-off you will be.

Production Planning – read as much as you can about TV production (although it is unlikely to be specific to wildlife, it will still be very useful) – the PACT guides are pricey but very informative (more information about PACT in the chapter *Organisations, Projects and Further Information*). Pretend you are in charge of a new production and go through every part that a producer will have to deal with. Make copious notes and flow charts – plan everything you will require to realise the production (staff, equipment, logisitics etc) – cost everything up and prepare a budget and timescale.

Research – choose a topic for a film and go through the research process. Use libraries and the Internet to find out as much about the subject as you can, and condense your notes to the facts that you think will be most relevant for the film idea. Get to know the most effective and quickest routes to get the information you need.

Writing – study award-winning scripts and practise writing your own. Examine subject-selection and story-line structures. Develop an idea for a wildlife film in your head and just start writing what you envisage the narrator saying. Then keep going back to it and re-writing. Get someone else to read it to you and see how it sounds. Take courses in creative writing (correspondence courses or at adult education centres). Find a mentor who can guide and advise you.

Camera work – assuming you can't afford to buy a Super 16 film camera and dive in at the deep end, the best way to start practising is with a DV camcorder. Even the cheapest palmcorder will at least get you taking moving pictures and analysing your results. Practise your camera skills and your fieldcraft together – then watch the footage on your TV and make notes about what you need to improve. How do the pictures compare to films you want to emulate? Learn to understand filmic-grammar. Improving your stills photography skills will also help you understand the basics of lighting, exposure, lenses, framing shots etc.

Sound recording – you can start to practise recording wildlife sound with almost any sort of portable recorder – DAT, Minidisc, open-reel tape (eg Nagra), even cassette tape. Get yourself a good directional microphone and you're off. Practise recording atmospheres as well as individual animal sounds, mono and stereo. Find the best methods of reducing hiss, and avoiding traffic and handling noise. Parabolic reflectors are not expensive and will help you pick up sounds from animals without having to get so close that you disturb them. Also practise editing the sound you record – the best method these days is to do it on your computer with software such as Sound Forge or CoolEdit 2000. Great advice can be had from the Wildlife Sound Recording Society (see the chapter Organisations, Projects and Further Information).

Picture Editing – a good way to start is with plenty of practice on your computer. Only recently have computers been able to handle the large file-sizes involved with video, so you are starting at a good time! You can get a video capture card (required to import, or 'capture', video onto your

computer) and editing software quite cheaply for your computer – the basic techniques will be the same as when you are using mega-expensive equipment in a state-of-the-art post-production studio! Experiment using sequences in different ways. Write and record a narration over the top – it will help you develop a flow for the production.

Presenting – team up with someone who wants to be a camera operator, and practise together! The more you do it the less self-conscious you will feel, and the less likely you will be to stumble on words (and tree roots). Develop your own style; watch other presenters on TV and analyse what they are doing. Get other people to watch your results and tell you what they really think. Write down their comments and make necessary changes. Work at it. It doesn't always come naturally – everyone can improve...

5. Network

It's true that it's often 'whom you know' not 'what you know' that gives you the biggest breaks in this industry. 'Networking' is simply meeting others in the industry, introducing yourself, getting your name and face known, seeking opportunities, selling yourself. It's vital, and it's a skill that doesn't come easily to some.

Letters, emails and phone-calls are some methods but there is nothing like meeting people face to face, and wildlife film festivals are the best place to do this. They are of such importance to this industry in particular that I have devoted a whole chapter to them.

Networking when you are young, unsure of yourself and unknown is far from easy. It's often a fine line between making a good impression and being a pain in the neck! You need confidence but humility, enthusiasm but respect. You need to be memorable, but for the right reasons! You need to leave people thinking – 'yes – I'd like to work with them' or 'they had some great ideas – I must remember them' etc. Be honest – tell people if you love their work and would love to work with them. There's no shame in admitting to nervousness, or in being direct about what you want.

Work, overall, on being the sort of person others will gladly want to work with. When I think of the people I have met at festivals and ended up working with, they have largely been people I simply liked and got on well with! Practise as much as you can and just go for it. Once you get stuck in you'll find you are talking to people with the same passions as yourself and it will get easier. More information about such techniques can be found later in the Festivals chapter.

Ways In

You are very unlikely to find an advert for your ideal job. Wildlife film production companies get so many unsolicited requests for work they rarely need to advertise positions (although some, like the BBC, advertise on principle). Occasionally jobs are advertised in Wildlife Film News but it is not common! Other posts can sometimes be found in the national press, but it is best to assume you have to be more pro-active in your job-hunting.

Good advice about starting out in some of the specific careers related to wildlife film can be found by studying the particular case studies in the previous chapter. In addition let's now look at a few of the common ways in:

If you are interested in a career in production, there are a number of ways to get a foot in the door:

• Approach production companies for work-experience as an assistant/runner/researcher/dogsbody... This may be unpaid, or for a very small wage if you're lucky, but it will be a foot in. Once there, you will learn huge amounts about how the whole business works, and when you impress all around with your enthusiasm, efficiency and ideas you will be in a good position when a proper job becomes vacant.

You will find contact details for various production companies at www.wildlife-film.com and in festival directories, as well as in publications such as RealScreen. Approach with a brief covering letter explaining exactly what you are looking for, and your CV/résumé. Bear in mind that this has to impress within a matter of seconds – busy people with a stack of mail to get through are not suddenly going to stop work for twenty minutes to wade through your unsolicited life story.

The Ideal CV/résumé

Name:
Photo
Date of birth:
Marital status:
Address:
Phone:
Email:
Website:

Qualifications summary – start with highest/most recent – qualification, grade and institution.

work-experience – start with most recent – job title, whom you worked for, where, what you did, dates etc. Be brief – do not include any short jobs of no relevance.

Other information – skills not mentioned before eg scuba diving, climbing, stills photography, writing and so on. Briefly mention your interests and goals in life.

Referees – name, title, address, email of two referees – ideally a recent employer and an educator.

The whole thing should be no longer than two pages – stapled together. Tailor your CV to the job you are applying for – make every word count. Double check spelling and grammar. Lay it out attractively to make it stand out from the hundreds of others - and print on good quality paper.

• Some entrants to the wildlife film industry started their careers by working in other areas of television – news or children's programme production for example. You may find these genres easier to get into, then you can learn skills and approach the wildlife producers with more ammunition.

• Pitch an idea. If you have a great idea for a programme (and better still – the contacts/access to the story) then you can pitch the idea directly to a production company/distributor/broadcaster. Ideally send no more than one page introduction and one page synopsis, plus your CV. In your covering letter explain exactly what you see your role being (eg researcher) and be realistic – you won't be taken on as producer if you have no previous experience. You may find the following exercise useful as a template:

TV Programme Proposal

1. Describe the primary purpose of the production, eg information, education, entertainment ...

2. What is the target network/channel and target audience (ie general TV audience, children's TV, schools TV, university TV, etc)?

3. What is the subject of the programme, ie its topic? (One sentence only; you will later expand in the synopsis).

4. Give a possible title of the programme.

5. What is the intended shooting format, eg film or video tape, or both (specify gauges)?

6. Describe the style of the production, eg in-vision presenter? with music? low/middle/highbrow?

7. What is the proposed length in minutes?

8. What type of story-line have you planned (not the story-line itself), eg round-the-year, journey, life-cycle, problem/study/solution, past/present/future etc?

9. Write a synopsis of the programme content in story-line order, ie outline of the story – the sequential arrangement of the content: beginning, middle, end. (What commonly can go wrong here is that an assembly of interesting facts, grouped by association round a topic, is listed; whereas what the potential commissioner needs to read, is an unfolding progression. He/she wants to understand the 'plot'; how the viewers' interest will be held and satisfied by the way the programme is structured). Make clear also, what we will see!

Carefully research and target the companies you approach. Find out what sort of programmes they produce and where they are broadcast, and pitch to the sort of companies who already produce programmes in a similar style, and for a similar output, to your idea. Find out the name of the right person to send your pitch to and whether they have any guidelines.

Be aware – ideas can get stolen! There is a minority of unscrupulous producers who may find out all they can about your killer idea and then go and make the film without you. BUT – this is really rare, and if you keep your film to yourself it will never get made. Remember it is 'only an idea', and you

should have lots of other ideas, and in any case many people may already have had the same idea and approached the same company with it!

If you are looking for camera-work then the following are possible routes in:

• Approach camera operators to see if they need an assistant. This may well be unpaid, and you may even have to offer to pay your travel and expenses along the way, but it will be invaluable experience if you can get it. It will certainly be hard work and you may have to do everything from carrying equipment to driving and cooking. You can either contact camera operators directly (you'll find them listed in www.wildlife-film.com and festival directories, and it's worth approaching The International Association of Wildlife Film-Makers), or approach production companies and ask if they have any camera assistant work-experience/shadowing with any of their camera operators. 'Shadowing' basically means you just accompany a camera operator (unpaid of course) and learn from watching them. If you're lucky they will teach you a great deal.

• If you are already skilled enough you can approach a company with your showreel on video/CD-ROM/DVD. This should be about 5 minutes (never more than 10) of varied footage showing what you are capable of. It could accompany a pitch if you have a strong film idea as well. It has to be stunning – or why should they use you rather than the camera operators they are accustomed to using?

Below you will find a guide to producing an ideal showreel. Package it in a video box with a beautifully designed inlay card, with colour shots and title. Also – address, phone, email, website, details of equipment available, and locations for material on the showreel.

Camera Operator's Showreel

Opening Titles, white on black:
"SHOWREEL by xxxx xxxx, camera operator
Running time, 5 min 23 sec"

Then the suggestion is three different items:

Item 1: Show that you know how to take different kinds of shot, each one to be untrimmed, ie at 'rushes' length, as each could have come out of the camera. Put in one or two of each of the following with a half-second of black space between each. To also demonstrate that you have an eye for a picture and imaginative ideas; each subject to be well-chosen – to make real use of the shot type

Title: "SHOT-TAKING"
Locked-off shots – Black
Survey pan left, survey pan right, follow pan left, follow pan right
Whip pan left, whip pan right – Black
Tilt up, tilt down – Black
Zoom in, zoom out – Black
Track forward (steady), track back (steady), track forward (human p.o.v.) – Black
Lift up, lift down

Item 2: This could present 3 minutes (12–20 shots) of material all on one subject, perhaps all one 'action', to demonstrate ability to shoot material that will make a sequence – to give, when edited, an illusion of continuity. Assemble the shots in sequence story-line order, but don't otherwise edit – leave each shot at its camera-original length. Include an obvious cutaway or two. Subject matter should be very different from anything in Item 1.

Title: "SHOTS FOR A SEQUENCE – UNEDITED"

Item 3: This could be a) an extract from a production to which you contributed; or b) an edited sequence to show your special interest (eg undersea, insects, or cutting pictures to music); or c) an edited 'promo' – two minutes for a programme idea of your own you'd like to be involved in, in the future. Subject matter should be very different from that in Items I and 2.

Title: "EDITED SEQUENCE"

End Credit: white on black:

"Material © xxxx xxxx. Address, phone, email,website."

If you want to be a presenter then again one approach is to target production companies with a showreel. It is incredibly competitive. Companies get many tapes from wannabe wildlife film presenters – and many of them are dreadful! Don't send yours in until you are sure it is as perfect as you can achieve – practise endlessly, get feedback, develop your style. Don't spend years waiting to be discovered – get a life in the meantime! If you can get work-experience with a production company, for example, you will better placed in the future to land your showreel-to-die-for on the appropriate desk.

Wannabe wildlife sound recordists can compile an audio audition tape/CD. You may also get unpaid work-experience by shadowing an accomplished sound recordist. Another approach is to contact camera operators directly to see if they need someone to help on the sound side with any forthcoming projects. You can also increase your skills by working in sound in a different genre – other areas of television or video or music production for example – it's all good experience.

Give particular attention to how you approach a potential employer, and then how you follow up if someone has given you their time. Bryan Smith finds that people often make mistakes at this stage, and has the following advice to give:

Bryan Smith
Executive Vice President, Programming and Production
National Geographic Channels International

(The following is extracted with permission from Bryan Smith's book *Desperately Seeking Screentime* – 1994 Simon & Schuster Australia)

APPROACH

• When applying for a job, if your application form contains bad spelling and punctuation you are unlikely to get an interview.

• One approach is a three paragraph letter saying, 'Here is what I do. Here is what I want to do. Can I send you my résumé/CV?' By making it short and to the point what you are subliminally conveying to the receiver is that you understand they are busy, and so twenty seconds is probably as much time as they can allocate to reading your letter. If you spark their interest they will respond with a request for your résumé.

• If you start your letter with 'I'm the one you want,' then it is unlikely you will be taken seriously. Likewise, people who put their résumé inside a balloon filled with glitter and have it delivered to the production office are destined for failure. What is called for is an expression of your creativity within the boundaries of accepted business practices.

• If your résumé is requested, then what is needed is not a twenty-page tome on everything you have done in your life, but rather a two- to three-page summary of what you have done: including details on your schooling and any tertiary study you have undertaken; the precise nature of the jobs you undertook and their durations, along with the names of people you worked with. If you don't have actual work experience, then assemble evidence of your commitment.

• It is also quite appropriate to mention in your cover letter that you will telephone in a week's time to check that your résumé has been received. That gives the production office time to send out a 'No Thanks' letter, if that is their verdict. If this is the case, you might then set about finding out why you were rejected to ward against the same fate next time.

FOLLOW THROUGH

• If you are unsuccessful at interview, respond with at least a thank you note, hopefully including some information that might be useful to those who gave their time to interview you. Then you might be able to follow up with a phone call to someone on the interviewing panel to find out why you didn't get the job.

• You will also need to keep your name in front of the person or people who interviewed you, so if a vacancy should arise you are likely to be amongst the first they will think of. A warning though: there is a vast difference between persistence and pestering. A call or follow-up note twice a month would be the upper-limit of contact before it got into the counterproductive, pestering category.

• Be persistent. Everyone who is working in television has stories about people who didn't give them a job, so just keep picking up the phone and keep trying.

• When you don't get a job you desperately wanted, it is very easy to blame yourself. But don't assume the person interviewing you for the job has any clue about what they are doing. They may be a wonderful producer, but it doesn't necessarily follow that they are skilled at spotting talent!

• Keep faith in yourself, because real talent will ultimately shine through and be recognised.

• When you do make it, don't close the door be-hind you. Try to remember your struggle, and pull through someone else of talent.

Don't forget this is a very varied industry and there are other opportunities besides the conventional production company/television route. Some have successful careers using their skills for multimedia productions or for education and conservation. Some combine working part-time on wildlife films with other work (such as producing commercials) or with completely unrelated ventures. Others do not pigeon-hole themselves with just one job/skill but take on a variety of work such as writing, narrating, editing – freelancing here and there as they find the work. Job security is not what it was, to say the least! Adaptability and flexibility are key for survival (no pun intended!).

Above all you have to CREATE YOUR OPPORTUNITIES. No-one will come and seek you out – you have to be pro-active – and you must be passionate about the business. Be positive – forward-thinking – seize every chance you can – plan – focus – put yourself in the right places – get yourself known for the right reasons!

Your life is your work of art. Make it a good one!

Ethics

One other important consideration for newcomers is that of ethics while film-making. You should recognise that the welfare of an animal is more important than the sequence; that you have a responsibility to ensure that nothing you do could reasonably be considered cruel; and that you should not have a detrimental effect on the ecological integrity of the ecosystem you are working in.

Filmmakers for Conservation (FFC – further information about this organisation in the chapter *Organisations, Projects and Further information*) have developed the following guidelines:

FFC GUIDING PRINCIPLES FOR DOCUMENTARY MAKERS

PRINCIPLES

1. Always place the welfare of the subject above all else.

2. Ensure that your subjects are not caused any physical harm, anxiety, consequential predation or lessened reproductive success by your activities.

3. Don't do anything that will permanently alter the natural behaviour of your subject. Be aware that habituation, baiting, and feeding may place your subjects at risk and may be lethal.

4. It is unacceptable to restrict or restrain an animal by any means to attract a predator.

5. Subjects should never be drugged or restrained in order to alter their behaviour for the sole purpose of filming.

6. Be aware of, and follow, all local and national laws regarding wildlife where you are filming.

7. Be courteous to your contributors (give appropriate credit where it is due). Whenever possible give copies of the finished programme, a copy of a long edit of an appropriate scene, and/or publicity photographs to the people who helped you.

8. Images or script that give an audience abnormal, false or misleading information about a subject or its behaviour should be avoided.

9. Always research your subject before filming.

GUIDELINES FOR WORKING IN THE FIELD

1. Restore all sites to their original state before you leave (for example: tie back rather than cut vegetation).

2. Be aware and take precautions, as some species will permanently quit a site just because of your odour.

3. Keep film, video equipment, and crew-members at a distance sufficient to avoid site or subject disturbance.

4. Night shooting with artificial lights can require precautions to avoid making the subject vulnerable to predation.

5. Be prepared to meet unexpected conditions without damaging the environment or subject. Be especially prepared and deal with any people attracted by your activities as they could put the subject at risk.

6. Be aware that filming a den or nest site could attract predators.

7. The use of tame or captive animals should be acknowledged. If using tame or captive animals:

> a. Ensure the subject receives proper care.
> b. The subject's trainer or custodian should always be present during filming.

Education and Training

One of the questions I am most often asked is 'what qualifications do a wildlife film-maker need?' Of course there is no easy answer to this. Some of the most successful people have almost no qualifications – certainly no relevant ones – while there are others who would not have got where they are today without a university degree in zoology.

Factors affecting the qualifications you should aim for are:

• Your age
• Your academic potential
• Your interests
• The sort of job you are aiming for
• Whether you want to be employed or freelance

Many other factors are often more important than qualifications in this industry – determination, enthusiasm, talent, experience for example. But, having said that, qualifications will always be a positive attribute, and in some cases are essential.

In all jobs connected with wildlife film-making the more you know about natural history the better. Much knowledge should come from your own interest, but qualifications in biology/zoology should certainly be pursued at school. Whether you go on to take a university degree depends on what you want to do – if you want to work in production with a large company, for example, then a biology/zoology degree will be highly desirable – sometimes a prerequisite.

If you're a school-leaver and not sure exactly what you want to do – but know you want to work in the wildlife film-making industry – then a degree is probably the next-best step. Having said that I would definitely advise talking at least a year off before going to university. Get some experience of life/travel/the world etc and it will help you clarify your direction.

If you are a graduate seeking further qualifications there are various possibilities such as the specific postgraduate courses in Natural History Film-making (see the institutions listed later in this chapter for further details). These courses are an excellent background but occur only in a couple of places in the world – so are beyond the reach/means of many people.

If you want to specialise in some aspect of natural history then you could follow other postgraduate routes such as a doctorate (PhD). If you specialised in ape behaviour for example, this may help you get work on an

ape film (as researcher/producer), but you need to be aware that you cannot always expect to work in your chosen area of interest – so good general knowledge is important too.

Another approach is to take the film-school route. There are many film schools throughout the world (as this is an international book we can't possibly list them all) and some have excellent courses specialising in documentary production. This route is more applicable if you are aiming for work as a camera operator, video editor etc – but, like biological qualifications, film-school qualifications can be useful whatever you do, giving you a great technological base.

For those without the time/means/inclination/academic ability to take three years or so to do a degree, there are plenty of other options for further training. Wildlife Film Festivals run various excellent workshops and masterclasses as you will see in more detail in the next chapter. Often associated with festivals are other courses such as Jeffery Boswall's Wildlife Televison Training courses (see later for details) or Film Workshops' wildlife film and video workshops.

For those wishing to improve certain specific skills there are short courses in all manner of technical and production skills (not specific to wildlife) at various colleges, training institutions, and studios. For example you can take short courses (from a day or two to a few weeks) in subjects such as Avid editing, script-writing, DV camera operation etc. Of course you have to pay for these courses and they can be quite expensive. Bear in mind that experience in areas beyond your speciality may be very beneficial – for example if you intend to be a camera operator, but get a chance to do an editing course, then this will help you to understand how a film is put together, and what sort of footage is needed to create the finished product.

If you are employed by a larger production company then they should be willing to send you on a variety of short courses to improve your skills and enhance your career prospects – take every training opportunity you can. For some, the perfect start will be work-experience with a production company that also sends you on a number of training courses.

For those aiming to be freelance it is true to say that your experience and skill is more important than qualifications as discussed in the previous chapter. Particularly if you have camera operator ambitions, your showreel will be your most important tool – but having said that, any background knowledge/training you have in natural history and film production techniques will be to your advantage, and help you to get a more complete picture of the industry.

The following opportunities are highlighted as they are specific to wildlife film-making and welcome students from all over the world:

Master of Fine Arts Program in Science and Natural History Filmmaking

Montana State University USA
Department of Media and Theatre Arts
Ronald Tobias, Director
Graduate Program in Science and Natural History Filmmaking
Phone: +1 (406) 994-5884
Fax: +1 (406) 994-4591
Email: naturefilm@montana.edu
Website: http://naturefilm.montana.edu

The graduate curriculum offers an extended range of courses in production, history, and theory in science and natural history film. The program takes three years to complete and results in a Master of Fine Arts degree. Students normally have professional production credits by the time they graduate. For a complete listing of the courses we offer, please consult our website.

The majority of courses are conducted on the main campus of Montana State University in Bozeman. Students may enter the program during the Fall semester only. Montana State University is located in the Northern Rockies a short distance from Yellowstone National Park and a few hours from Glacier National Park.

We offer the only degree program in Science and Natural History Filmmaking in the world. Applicants seeking admission must either have a degree in science, engineering, or technology or a declared minor in a science or the equivalent of a declared minor. We actively seek people who have some experience, however limited, in film-making and science backgrounds, although many students who enter the program have no experience in film-making at all.

The program has very close ties to its major underwriter, Discovery Communications, the parent company of The Discovery Channel, The Learning Channel, Animal Planet and the new Discovery Science Channel. Our students have exceptional opportunities to produce for the various networks. The program also receives extensive support from SONY, Fujinon, and Kodak. We offer state-of-the-art equipment to students, including three High Definition Video packages, including a 24p system, DSR-500s, and a Super 16mm Aaton XTR camera. Students may elect to work with a variety of national museums or federal agencies (including the National Park Service, NASA, and the National Science Foundation). The program offers exceptional opportunities for internships and fellowships both on campus on with broadcasters and federal agencies.

The film school at Montana State has fourteen faculties in film and video production and extensive production facilities including two sound stages.

Postgraduate Diploma in Natural History Filmmaking and Communication

University of Otago
(in association with Natural History New Zealand)
Associate Professor Lloyd S. Davis
Director Postgraduate Diploma in Natural History Filmmaking and Communication
Department of Zoology
P.O. Box 56, Dunedin, New Zealand
Phone: +64 (3) 479 7654
Email: naturalhistory@otago.ac.nz
Website: www.otago.ac.nz/zoology/naturalhistory/index.html

The University of Otago's Postgraduate Diploma in Natural History Filmmaking and Communication is a one-year full-time programme taught in collaboration with Natural History New Zealand, the second-largest producer of natural history documentaries in the world. The programme consists of six papers:

NHFC 401: The Techniques of Natural History Filmmaking
This is a seminar-based paper that deals with the process of making a natural history documentary. It covers the technical aspects of natural history film-making, such as the use of equipment and the roles of those involved.

NHFC 402: The Craft of Natural History Storytelling
This is a seminar-based paper that explores the requirements for the core skill necessary for the communication of science and natural history – telling a story. It aims to develop the crucial research skills required to put together effective stories and to equip participants with key skills needed to take an idea and develop it into a script.

NHFC 403: Biology as Natural History
This is a seminar-based paper that examines how biological science can best be popularized. While concentrating on the role of natural history documentaries as vehicles for conveying science to the public, it also considers other forms of media, including magazines, books, museum displays, CD/DVD-roms and the Internet.

NHFC 404: Internships
This provides for an 8-week part-time work (or 4 weeks full-time) internship at an appropriate facility, where the student takes part in an approved aspect of natural history film-making or an approved alternative involving the communication of science.

NHFC 405: Natural History Documentary
This paper involves the production of a commercial half-hour natural history documentary.

DESI 401: Digital Media Design
This is a seminar- and practical-based paper that aims to develop understanding and skills in the areas of multimedia interface design, digital sound and video, and multimedia authoring.

When/where they are held:
Dunedin is the wildlife capital of New Zealand with seals, albatross and penguins all living within the city's boundaries. It is perhaps no accident, then, that it has also become a centre for those involved in natural history film-making and popularizing science.

The programme runs from early July until the following June and is restricted to twelve students per annum. Applicants must have a university degree. Experience or qualifications in film, photography, popular writing or design will also be taken into account. Applicants are advised to put together a portfolio that illustrates their creative capabilities.

International Film
WORKSHOPS

PO Box 200 • Rockport, ME 04856

Phone: toll free (in USA): 877-577-7700
Email: info@TheWorkshops.com
Website: www.FilmWorkshops.com

120 one- and two-week professional workshops and master classes in wildlife, nature, historical and social documentary film and television. You can spend a week or a month with BBC, PBS, Discovery and National Geographic film-makers and photographers learning to work as a professional, or to improve your career options. There are courses in writing, developing and funding TV documentaries, wildlife field production, expedition management, 16mm film and digital video cameras, sound recording and editing. The Workshops is a Certified Apple Final Cut Pro Training Center and offers courses in Avid DV editing, editing TV documentaries and HD Video Cinematography. Join documentary expeditions to Mexico, Cuba, South America, Crete, Spain and Africa to film endangered species for the Africa Fund. New programs offered each year. Based in Rockport, Maine.

Wildlife Television Training

Jeffery Boswall with course participants

Jeffery Boswall, Birdswell, Wraxall, Bristol BS48 1JZ UK
Tel/Fax: +44 (0) 1275 853418
Email: jeffery_boswall@hotmail.com

Wildlife Television Training – an International Consultancy for Wildlife/Environment, Film/TV/Video. To inspire newcomers and refresh older-comers. Course storyline: from conception to delivery, covering significant aspects of pre-production, production and post-production. From having one idea to having its successor!

Jeffery Boswall was a BBC Natural History Unit television producer for 24 years. He then ran the film and video unit of the RSPB for six years before being appointed a senior lecturer in wildlife TV at the University of Derby. He is now a freelance presenter of wildlife/environmental film/video programme-making courses and has taught them in UK, USA, Latvia, Estonia, Italy and elsewhere.

Science and the Media Degree
Royal Holloway, University of London, Egham, Surrey TW20 0EX UK
Phone: +44(0)1784 434455
Website: www.rhul.ac.uk

Science and the Media (Biological Sciences) is an innovative combined honours degree programme which links the strengths of Media Arts and Biological Sciences at Royal Holloway. Students major in either Biology or Biochemistry, which constitute three-quarters of the degree programme. Media courses in all three years are run specifically for Science and the Media students from this department plus Geology and Physics.

Wildeye - Wildlife Filmmakers' Training
Email: info@wildeye.co.uk
Website: www.wildeye.co.uk

Wildeye run a number of courses, workshops and training expeditions for aspiring wildlife film-makers. If you are just starting out we suggest you start with the Introduction to Wildlife Film-making weekend in Norfolk, UK. From there you can go on to take more specialist weekend courses such as editing, sound recording or camera work, or go on one of the experience trips such as the Big Cat Film Safari in Kenya or Bimini Shark Encounter in the Bahamas.

Wildlife Film Festivals

Because of the very nature of this industry – with personnel spread all over the world, often in remote areas – festivals where the industry gets together are perhaps more important than in any other arm of film and television.

Some people go to all the major festivals, some just go regularly to their favourite, or most local one. It is a chance to learn, network, do deals, meet old friends and make new ones.

In general most of the major wildlife film festivals feature:

• **Workshops** – led by experts in their field – eg underwater filming techniques, script-writing, Avid editing etc.

• **Seminars and masterclasses** – topics, new issues and technologies debated by leading professionals.

• **Trade Shows** – displays of equipment, accessories and related services – enabling you to see and try the latest gadgets and talk to suppliers.

• **Awards competitions** – often hundreds of films are entered into a competition where they are judged (in advance of the festival) in categories such as 'Best Cinematography', 'Best Sound', 'Best Editing' etc. The results are usually announced at an awards ceremony during the festival.
Most festivals have a Newcomers' Award – and entering a film in this category is often free or at a greatly reduced rate.

• **Screenings** – a chance to see many of the films entered into the awards competition – usually in a large screen cinema. There are often also private video booths where you can watch any of the competition entrants that you wish – great for research and catching up on some programme you missed.

• **Social events** – drinks, suppers, happy hours and parties, often hosted by the larger companies. A chance for social networking – and to have fun!

• **Special events** – most festivals also feature an array of special events such as lectures by prominent people, exhibitions, meetings, debates and concerts.

Festivals last from a few days to a week, and are either annual or biennial. Attendance can be expensive – especially when you include travel and accommodation – but they really are a fabulous opportunity for newcomers to learn more about their art, and meet the professionals in whose footsteps they wish to follow. Note that many festivals take volunteer helpers – this is

a good way to get to a festival cheaply, get to know other people and have fun in the process – but you do have to work! Some also have concessionary rates for first time attendees. Approach each festival for further information about this.

You can apply to attend a festival (be a 'delegate') from a few months before the festival starts – and often you will find reduced rates when applying far enough in advance – so check out the festival's website for information well beforehand. Note that entries for awards such as the Newcomers' Award will also be required some months in advance of the festival itself.

When you attend festivals as a newcomer it is advisable to bear a few points in mind:

• If you are looking for a job by all means bring copies of your CV/ résumé, but bear in mind that many others will be doing the same. Make your CV brief but enthusiastic, and include a photo within the text so that people may remember having met you! Be clear about what sort of job you are looking for, and carefully target the people you approach.

• If you are bringing a proposal for a production then it is best to limit this to a couple of pages (see the TV Programme Proposal guide in the chapter *How to Get Started*). If you have video copies of your work/proposal then bring these but don't give them out unless asked for. Busy people with bulging delegates' bags will not want to cart around piles of video cassettes. Also be aware of the format of your tapes (eg **PAL/NTSC) although most companies can view both these days, that is not always the case.

** PAL is a standard for video (tapes and players/recorders/cameras) in parts of Europe, Africa, Asia, Australia etc. PAL (625 lines at 50 Hz) is incompatible with NTSC (525 lines at 60 Hz) which is the standard in America and Canada. There are other standards such as SECAM but PAL and NTSC are by far the most common.

• Be prepared to talk to lots of people you've never met before – throw yourself into it with enthusiasm and immerse yourself in an exciting environment where you will be surrounded by people who share your passion.

• When talking to prospective employers, commissioning editors, mentors, heroes etc, remember that they will be very busy, and will have a lot of other people to talk to (including others queuing up to ask the same things you just have). Be polite, enthusiastic, and get to the point quickly. If they start looking over your shoulder as you drone on about your amazing idea for a micro-camera you can strap to a beetle's back – you've gone on too long already! Don't be loud, pushy, too persistent, or drink too much!

• Take lots of business cards – which explain briefly what you do (or want to do) as well as carrying your contact details.

• Take advantage of as many of the events as you can – by the end of the festival you should be exhausted, but will also feel energised from having met so many people with whom you have so much in common.

The number and variety of wildlife film festivals throughout the world is increasing all the time – the major international ones are now described:

The International Festival of Moving Images from the Natural World
WILDSCREEN, Anchor Road, Bristol BS1 5TT UK
Phone: +44 (0) 117 915 7104
Email: info@wildscreen.org.uk
Website: www.wildscreen.org.uk

Wildscreen is held in Bristol biennially on even years (2002, 2004 etc) during the month of October. It lasts one week, usually Sunday – Friday. In 2000 there were 850 delegates from 46 countries.

Wildscreen is the world's largest festival of moving images from the natural world. Established in 1982, it was initially dedicated to wildlife and natural history programme-making, specifically television, but its remit today covers all aspects of screen-based natural history communications including the Internet, interactive medias and film formats such as IMAX.

Over the years, Bristol has become recognised as the world's capital of wildlife film-making. The Festival is an opportunity for people from all around the world to gather to discuss technical, editorial and scientific developments in their industry. It brings together the world's top wildlife and conservation film-makers, leading environmentalists, scientists, zoologists and commissioning editors and students.

The Festival offers seminars, screenings, discussions, master-classes, training workshops, networking events, trade shows as well as providing an arena for delegates and, importantly, the general public to see outstanding natural history films from around the globe on the big screen. It culminates in the Award Ceremony.

The Festival especially encourages entries from newcomers, with discounted entry rates for film entries to the BBC Newcomer Award category and limited concessionary delegate rates for first-time delegates 30 year old and under. During the Festival week Wildscreen also takes on between 25 – 30 volunteers.

WILDLIFE FILM FESTIVAL

P.O. Box 3940, 125 East Pearl Street, Jackson, Wyoming 83001 USA
Phone: +1 (307) 733-7016
Fax: +1 (307) 733-7376
Email: info@jhfestival.org
Website www.Jhfestival.org

The Jackson Hole Wildlife Film Festival, held in the fall of each odd-numbered year (2003, 2005 etc), is an unparalleled industry gathering focused on film competition, cutting-edge equipment presentations, and an exceptional slate of seminars, panel discussions, and screenings. The Festival is attended by hundreds of television and film professionals from more than 30 countries. Set against what is held by many to be one of the most scenic natural settings in North America – the Grand Teton mountain range and surrounding Jackson Hole valley – the Festival and its majestic backdrop are both inspirational and enlightening.

The Festival culminates each year in a gala Awards Ceremony and dinner where the best examples of the natural history film-making art are honored along with their producers. The honorees and their films represent a very select group, judged from over 600 film entries by a distinguished panel of industry experts, with special categories for Newcomers.

The Jackson Hole Symposium, held in even numbered years (2002, 2004 etc), is focused specifically on new production techniques, cutting-edge technologies, and emerging markets for natural history producers and film-makers. The three-day Symposium is limited to a smaller group of participating delegates to ensure for each participant the opportunity for immersive involvement in seminars and panel discussions, and to provide a meaningful hands-on experience with new techniques and technologies.

The Symposium is directed toward practical and tangible demonstrations and discussions of the most exciting new technologies and market opportunities.

718 S. Higgins Ave, Missoula, MT 59801 USA
Phone: +1 406.728.9380
Fax: +1 406.728.2881
Email: iwff@wildlifefilms.org
Website: www.wildlifefilms.org

The International Wildlife Film Festival is held every year in April with an attendance of 10,000 (public). 200-300 films are entered into the competition. Entry fees vary depending on the category.

Awards: Best of Festival, Best of Category, Best of Craft; Photography, Sound Effects, Editing, Script, Narration, Animal Behavior, Use of Graphics and Animation, Educational Value, Scientific Content and Merit Awards for areas of excellence.

Created and based in Missoula, Montana USA, the International Wildlife Film Festival is the world's longest – running juried wildlife film competition and festival. The Missoula Festival hosts a wide range of special events, workshops, seminars, public and private screenings, panel discussions and receptions.

The mission and philosophy of the IWFF is to foster knowledge and understanding of wildlife and habitat through excellent and honest wildlife films and other media. The IWFF strives to build bridges for the people who are involved in wildlife, film-making, and distribution.

Organisations, Projects and Further Information

The following are international organisations, projects and sources of further information – you may well find additional useful contacts in your own country.

Wildlife Film News

Contact: Piers Warren (Editor)
Email: info@wildlife-film.com

Since July 1999 the free monthly e-zine Wildlife Film News has been emailed to an increasing number of subscribers. It is now read by thousands of people involved with, or interested in, the wildlife film industry, from over one hundred countries.

Issues typically include news about festivals, personnel wanted, equipment for sale, new productions, training opportunities, films winning awards and other general articles of interest to wildlife film-makers. As it is emailed it can spread news much more quickly than printed publications. To subscribe – visit the website www.wildlife-film.com (see below) and enter your email address on the 'Newsletter' page. Here you can also access all previous issues of the e-zine.

www.wildlife-film.com

This is the parent website of Wildlife Film News. The site contains news

articles of interest to wildlife film-makers and directories of producers, festivals, training opportunities, stock footage libraries, equipment suppliers, location managers, organisations, publications and freelance personnel.

This is a great site for research, finding contact details, keeping up with the latest goings-on in the industry worldwide and so on.

International Association of Wildlife Film-Makers

Contact: Hilary MacEwen (Secretary IAWF)
Phone: +44(0)1823 421 539
Fax: +44(0)1823 421 562
Email: macewen@globalnet.co.uk
Website: www.iawf.org.uk

The International Association of Wildlife Film-Makers (IAWF) was founded in 1982 to encourage communication and co-operation between colleagues who are often isolated in the field. It is an association for professional camera men and women and sound recordists earning most of their income from making wildlife films. Producers who do part or all of the camerawork on their projects are also very welcome to join. Worldwide membership currently stands at 206 from sixteen different countries, and includes many of the leading names in the industry.

With such a wealth of experience to draw upon, IAWF provides a friendly forum for sharing and solving practical, logistical, technical and contractual problems.

It publishes a Newsletter twice a year which keeps members abreast of industry news, technical developments and relevant happenings. There are plans to make the newsletter electronic in the near future. The website (www.iawf.co.uk) already provides a place for members to advertise their skills and experience, a place to buy and sell equipment, and a forum to discuss issues and share information.
In the past the IAWF has acted as an informal job recruitment agency, providing producers with details of suitable talent, and this role is now mainly handled by the Crewfinder section of the website.

Full membership is by election and candidates must have a proven track record. Associate membership is available to the less-experienced and is recognised as a very valuable means of gaining contacts, background knowledge, and access to expertise.

Email: info@filmmakersforconservation.org
Website: www.filmmakersforconservation.org

Although the environment has become an increasingly pressing concern over recent years, our industry has failed to give these issues the air-time that they deserve. Broadcasters around the world have on the one hand accepted the need and desire to address these issues whilst on the other have shied away from such programming, blaming a decline in viewing figures as the cause: "I don't like the 'e' word," as one broadcaster said. This issue has been a hot topic of debate for a number of years at various wildlife film festivals around the world. Each year our frustrations at this alarming situation have grown, provoking more and more passion but with little focus ... Until 1999 at Jackson Hole – the time and place of Filmmakers for Conservation's conception.

Filmmakers for Conservation (FFC) is THE global conservation organisation for the film and television industry – for the first time film-makers, broadcasters and conservationists can work side by side to tackle this problem head-on. Set up by wildlife film-makers and conservationists from around the world, FFC is the formal embodiment of the concerns that those belonging to the wildlife film-making community have for the environment and will become an invaluable resource for conservation organisations.

There is one thing that unites us all – our passion for nature and the environment. So if you care at all about the environment and the future of wildlife film-making, cast away the gloom that has befallen our great industry and make a most positive stand in support of world conservation by joining Filmmakers For Conservation. FFC has the potential to be a considerable force for change, with your help we will have the opportunity to make a real difference – for the benefit of the environment.

The mission of FFC is to promote global conservation through the making, broadcasting and distributing of films and to help conservation organizations and film-makers worldwide make more, better-informed and effective conservation films. FFC was founded during Wildscreen 2002 in response to increasing concerns from television producers and wildlife film-

makers that the environmental message was not being heard.

The Goals of FFC

1. Provide conservation organizations with a worldwide body dedicated to finding new ways of putting across their message through TV and associated media.
2. Liaise with conservation bodies to ensure film-makers are kept up-to-date on the latest and most pressing environmental stories.
3. Provide a forum for conservation organizations and film-makers to communicate, help each other and pool their efforts for more effective dissemination of the environmental message.
4. Campaign with broadcasters to increase the number of conservation films shown.
5. Sponsor the making of new conservation films.
6. Award the best conservation film-makers.
7. Provide information and encouragement to newcomers.
8. Provide guidelines for ethical film-making.
9. Find new ways of marketing and selling conservation issue films.
10. Provide a register of industry professionals who are willing to donate their time and expertise to conservation organizations.

Membership Information
The most important membership benefit is the personal satisfaction of belonging to and supporting a professional organization whose primary goal is to promote global conservation through the medium of moving images.

Benefits of FFC membership include:
• Access to the FFC Members directory
• Email postings, updates, Red Alerts and special notices
• Receiving Members only news bulletins by email
• Being eligible for nomination to receive special film-making or conservation achievement awards from the FFC
• Being eligible to apply for special funding from the FFC for conservation film projects
• Having access to the registry of professionals who have offered their time and experience to FFC members
• Having access to the Members only FFC forum
• Having access to organizational information such as Bylaws
• Participation in the Annual General Meeting

Further information and full joining details can be found on the FFC website.

An initiation of The Wildscreen Trust

The Wildscreen Trust, PO Box 366, Harbourside, Bristol, BS99 2HD
Email: info@arkive.org.uk
Website: www.arkive.org

ARKive will be the world's centralised digital library of footage and photographs of endangered species – a Noah's Ark for the on-line era, accessible to all via the Internet. Valuable and powerful images of the world's vanishing biodiversity are held in many different collections, scattered around the world, making access difficult. Saving the images, for research and education, is becoming an important resource to help save the species they depict.

Images and recordings are being donated to ARKive from the world's key wildlife film and picture libraries, natural history broadcasters, conservation organisations and private individuals. For each species, the on-line digital profile will include up to ten minutes of moving footage, six still images and two minutes of sound (where available), with copyright owners' details, simple text information for the lay audience and cross-references. ARKive's website will be going live towards the end of 2002, and the long-term aim is to compile digital profiles of all the world's Red Listed plants and animals that have been filmed or photographed.

Created by the Wildscreen Trust (organisers of the international Wildscreen Film Festival), ARKive's headquarters are in Bristol UK. Here there is a core team of media researchers (all biology graduates, with previous experience of working in wildlife film or picture libraries), educationalists and IT staff. ARKive is sometimes able to offer short work-experience placements.

This welcomes anyone with an interest in wildlife sound or a love of natural history.

Email: alanbrb@aol.com
Website: www.wildlife-sound.org

Founded in 1968, the Society is the oldest and largest wildlife sound recording society in the world, with members from most continents. It is in the forefront of reproducing natural sound, with many hundreds of members' recordings held in the National Sound Archive of the British Library.

Membership of the Society is open to all – whether or not they actively record wildlife sound. It brings:

• A Sound Magazine (on CD) produced each quarter. It compares and contrasts recordings made by members from around the world. Guidance on recording techniques, with examples, is also given.

• The opportunity to join fellow-members at Field Meetings and Technical Workshops which benefit the novice as well as the experienced recordist. The Field Meeting, held each Spring in an area chosen for its sound recording potential, is an opportunity to record, experiment and exchange ideas with other Society members. Technical Workshops are held every two years to give practical assistance in the use of equipment and techniques to record and analyse natural sounds.

• A high quality Journal, twice each year, containing articles on natural history, the nature, analysis and applications of wildlife sound, equipment and techniques for wildlife sound recording – and much more.

• Newsletters containing regular updates on forthcoming events and activities. Informed advice on technical matters – always available from experts within the Society.

• Competitions where members can enter recordings in several classes. The winner in each class is played on Members' Day.

• Members' Day, held with an optional evening meal each November. This includes the formality of the AGM and is a well-supported social occasion. It gives a further chance to obtain advice, share experiences and buy and sell members' equipment.

WSRS is a society renowned for its welcome to new members. It strives to help all who request assistance to enable them to obtain the maximum pleasure and benefit from recording, or the study of, natural sounds. Beginners and those partially sighted or unsighted are especially welcome.

Producers Alliance for Cinema and Television (PACT)

45 Mortimer Street, London W1N 7TD UK
Phone: +44(0)20 7331 6000
Fax: +44(0)20 7331 6700
e-mail: enquiries@pact.co.uk
Website: www.pact.co.uk

Founded in 1991, PACT has established itself as the only trade association in the UK representing independent television, feature film, animation and new media production companies. Representing over a thousand independent production companies, with a collective turnover exceeding £1.5 billion, PACT is governed by a Council elected by and from its membership to ensure that it represents their interests and aspirations. Publications include: The PACT Directory of Independent Producers, Art of the Deal, and The Production Handbook.

Further Reading:

RealScreen

#500, 366 Adelaide St West, Toronto, ON M5V 1R9 Canada
Phone: +1 416 408 2300 X444
Fax: +1 416 408 0870
Email: bchristie@brunico.com
Website: www.realscreen.com

RealScreen is an international monthly magazine completely devoted to non-fiction programming. From production, through distribution and broadcast, including suppliers and technology, RealScreen devotes its attention to all factual genres. Don't miss its annual Natural History Guide, available every September. See inside back cover of this book for further information.

BBC Wildlife Magazine

Email: wildlifemagazine@originpublishing.co.uk

BBC Wildlife is an award-winning monthly magazine that has the best and most informative writing of any consumer magazine in its field, accompanied by world-class photography. It publishes the latest discoveries, views and news on wildlife, conservation and environmental issues, provides further-information sources and is a 'must-read' for anyone with a passion for the subject. In addition to book and web reviews, it runs thought-provoking previews of forthcoming TV and radio programmes alongside a listings guide to all terrestrial channels. It has a worldwide reach, with subscribers in 87 countries.

Available monthly from news-stands. Subscriptions: UK / Europe and worldwide. Subscribe online www.wildeye.co.uk/bbcwildlife.htm

Wildlife Films by Derek Bousé

published by University of Pennsylvania Press 2000

This book is a scholarly analysis of the development of wildlife films up to the 21st century. Derek Bousé's exploration of wildlife film-making over the last few hundred years is fascinating, and the book is littered with behind-the-scenes anecdotes. Although the book focuses on the industry in the USA and UK, the discussions (to what extent are wildlife films documentaries for example) are applicable to wildlife film-makers the world over. There are so many well known names – both companies

and individuals – in the business today, and it's hard to keep track as units change name, merge or disappear. This book certainly helps piece the jigsaw together as the genre's development is analysed.

Derek Bousé says: "I wrote this book in part because wildlife film and television have been unfairly ignored by film historians and other scholars, who seem to have assumed that there is no 'art' to these films, no social relevance, and perhaps no significant-enough viewership or influence to warrant critical or scholarly attention. I've tried to show that the historical development of wildlife films is as rich and as colourful as any other area of film history, and that, as a contemporary form, wildlife films are as vibrant and creative as any other genre of popular film and television. In addition to critical investigation, then, part of my purpose was to stimulate interest in the subject. This book is certainly not intended as the last word. I hope students of environmental studies and natural history, as well as those interested in media studies, popular culture, and film history, will all find it relevant, readable, and a stimulus to further investigation."

Reel Nature by Gregg Mitman
published 1999 by Harvard University Press

In this book Gregg Mitman explores the history of nature films focusing on the conflict between the desire for scientific authenticity and the demand for audience-pleasing dramatisation. He discusses the driving forces behind the evolution of nature films over the decades, highlights good and bad nature film-makers, explores the relationship between scientific establishments and Hollywood, and analyses Disney's contributions to this genre and the huge success of natural history on TV. He finishes by concluding that while nature films help us to understand the natural world, the truth about our place in the web of life has been left on the cutting-room floor.

A Life on the Wild Side by Colin Willock
published 2002 by The World Pheasant Association

For nearly thirty years Colin Willock wrote and produced more than four hundred films in Anglia Television's famous wildlife series Survival, and now he has written a book of his fascinating and unique experiences during the pioneering days of wildlife film-making – A Life on the Wild Side. His work took him to some of the wildest places on earth, from the Arctic to the Antarctic. It also brought him the close companionship of some of the wildest – wild in the sense that they were in tune with nature – people on earth: wildlife cameramen, scientists, park wardens and rangers, animal catchers, bush pilots and eccentrics of the stature that only big, wild country can produce. A Life on the Wild Side is the story of these splendidly wild people and the wild places to which the author and his wife accompanied them. It is a story about the fun of wildlife film-making and the behind-the-scenes adventures that never reached the television screen – sometimes dangerous adventures, hilarious adventures, moving experiences and tragedies too.

The Future of the Industry

So, what's going to happen next?! The wildlife film industry is in a state of flux at the moment – but just over 100 years ago there was no wildlife film industry! It is a new industry, and with rapidly-advancing communication technology then of course it is going to be changing. The questions are: how is it going to change, and how are we going to adapt to this?

In order to try and answer these questions in as rounded a way as possible I have asked a number of people from different sectors of the industry for their thoughts. Some of the contributors to this section are very experienced, some are seeing it with relatively fresh eyes, some are deeply involved in actual production, others are looking at it from a different perspective.

Jane Krish
Chief Executive
The Wildscreen Trust

Oh for a crystal ball! With technology moving so fast, predicting the future makes life particularly difficult. Today, we have no real idea how ordinary people are going to respond to all these different technologies – including new generation mobile phones, digital TV, broadband – and how exactly they will affect future wildlife film-makers. Terrestrial television now has serious competition from multi-channel TV in most areas of the developed world.

Recently I received some statistics produced by the Independent Television Commission about viewing habits in the UK. It would appear that 50% of viewers now have access to multi-channel TV, Internet access at home doubled to 35% in 2001, and personal computers

and DVD ownership are also up.

So where does that leave you, the wildlife film-maker (apart from itching to get out there and make films)? Not only is there an increasing number of niche TV channels, but within the next five years (or less) a significant number of people will have access to broadband with the ability to download and view moving images that really move!

Today, television presentation on the free channels has become what is called, in the jargon, 'event' viewing, which means that the broadcasters must make a lot of noise to draw people's attention. Very few, in the UK at least, could have missed *Blue Planet*, thanks to the massive TV trailing and newspaper coverage that preceded it, not to mention the radio and TV chat show interviews, Festival Hall concert et al. *Blue Planet* also made fantastic use of the web and the interactive buttons on the remote.

Currently we are seeing an increasing divergence between television as entertainer and the web and digital TV as powerful educator (as long as you're looking in the right places). Lord Reith (the BBC's first Director General) wanted to allow access to news, information and events previously accessible only to a minority to become an everyday part of British life. It seems that television for educational purposes is no longer popular (remember *Life on Earth*?) and that information is migrating to the net. The species information on the BBC's nature site gives a wealth of detail that is often strikingly absent from broadcast programmes.

Getting a handle on trends around the globe is quite another issue. In some societies (for example the Philippines) virtually no-one possesses a personal computer but everyone owns a mobile phone. What does this open up? Will we in future be able to call up footage of species we wish to identify while on safari or visiting tropical forests?

And how do you – the newcomer to the wildlife film-making industry – pick your way through this techno-jungle? My main message is to keep abreast of all new developments in technology, delivery platforms and above all the market for content. Who is looking for what in which slots? To confuse the issue, some wildlife producers are spreading their wings and moving into adjacent genres so you end up with a mix of history and natural history or wildlife and science. Research is essential. Who round the world is actually broadcasting natural history, wildlife, conservation and what angles are they particularly looking for? What are their budgets?

Hone your existing skills and add to them. If your preference is for being behind the camera, then learn how to use field editing equipment and keep up-to-date with as many developments as you can. Get experience of filming in Super 16, 35mm (if you can), High Definition, DV – anything that will help you become indispensable. The best way of doing that is to attend industry shows and look things up on key industry websites.

Don't restrict yourself to the usual places. The snag is that the information

you require isn't that readily available. One place where you can glean some information is from the trade press: for instance RealScreen, a Canadian monthly that specialises in documentary, publishes an annual natural history supplement either for Wildscreen or for Jackson Hole. You can subscribe by email or get the publication. Better still you can attend the Festivals and meet the commissioners or listen to them in sessions.

As broadband does get taken up (already in Korea everyone has it) I believe that there will be an extraordinary number of opportunities because everyone will be very hungry for content. It's my personal view that technology is so clever we haven't yet begun to fathom how to adapt ideas to fulfil its potential!

Keep coming up with ideas, ideas and more ideas. If we don't raise awareness of the natural world in as many different ways as we can, frankly, there won't be any left to film anyway.

Brendan Christie
Editor
RealScreen

As the last millennium faded, viewers decided they'd had enough of the tried and true, and switched to shows in which people in bikinis voted other people in bikinis off islands. Many were concerned.

Sales of natural history fell. Companies closed. Mergers were frequent. Wildlife in film form fared as well as the real thing: extinction loomed.

Almost to quote from *The Sopranos*: 'Forget about it.'

Even in its bleakest moments, wildlife programming outsells all other factual programming, and it always will. Whether that's because wildlife travels well – owing to its traditionally featuring few talking heads, being mostly non-political, and having a long shelf life – or whether it's because we're not that far from the trees ourselves isn't clear. What is certain is that a realistic, well-prepared film-maker in this genre is far more likely to meet with success than counterparts in other factual disciplines. (There are also fewer release forms...)

Beyond the cyclical nature of the wildlife market – one that ebbs and flows at the best of times – several factors contributed to the recent down-turn: to begin with – although it may sound like a contradiction – explosive growth in

broadcasting outlets hurt the genre in the short term. International broadcasters launched channels using often-plundered libraries and over-taxed producers, forcing production prices down and making the business temporarily untenable for those on the bottom of the food chain. Revenues were diverted into international brand-building, invested heavily online, and used to fill every niche possible before competitors got there. The one thing each of these initiatives has in common is that the dollars only flow one way – out – away from content and producers. And when the recession hit, or at least when its chill was felt, advertisers threw the cash-flow into neutral and the screws turned a little tighter.

We're already seeing signs that the worst is behind us, and barring any major international upheaval, the wildlife market will rebound. The broadcast brands will establish themselves in their new markets. Ad sales will recover (although not to the levels seen in the last decade), sponsorships and corporate dollars will increase, and the burden will slowly be lifted from the producer and distributor. The outlets will also burn through their stockpile of material and will have to increase production or risk losing market share through repetition.

So, since the broadcast world seems to be sorting itself out, everything should be hunky-dory, right? Well, not quite. The biggest threat to natural history film-makers isn't external, it's internal. Wildlife film-makers are usually their own worst enemies for two common reasons: first, and most important, a large percentage forget they're running a business. Regardless of motivation or intention, film-making is an occupation and a camera only functions as well as the business plan powering it.

The down-turn has been hard on a lot of operations, but things will recover. However, all indicators point to a two-tiered rally, with the market divided into the high-end blue-chip region (several million dollars per film) and the volume fare for cable ($150,000 or less), with the primary broadcaster coming in for 40% or less. Film-makers need to plan accordingly. Decide on a broadcast format that fits your plan. Decide on the technology that will best serve your story and your budget, or that can at least be reasonably amortized over several projects. Choose stories you can cover, and work to a realistic schedule.

New film-makers should mentor with experienced film-makers to learn the tricks – and not just the film tricks. Learn about insurance from people who have dealt with the worst scenarios. Learn how deals can go horribly wrong so you're prepared. Get yourself a distributor and write down everything they say. Watch a lot of TV. Remember that small business courses are as important as those for your craft. And perhaps most critical, new film-makers need to educate themselves about the global market, both because international partnerships are vital and because opportunities exist globally.

The second area in which natural history film-makers are sometimes lacking is in the evolution of their content. To put it frankly, too many natural history film-makers have been making bad films, using approaches the market can

no longer afford and covering ground with which audiences are bored. Too many film-makers make the films they grew up watching. Now that television is only one of a dozen electronic distractions in the home, four-minute pans across the African savanna just don't hold people like they used to. (I've got a great idea for a natural history series: get a dozen people on an island, make them survive off the land, and once a week they get to vote one person off...)

Everyone has heard the truism that it's all about 'good stories well told', and that's not a bad place to start. I prefer Sorious Samura's (Cry Freetown) observation – granted, he said it in relation to the horrors of Sierra Leone, but it applies equally here: 'make the important interesting'. Give your audiences a reason to care, and entertain them while you're doing it.

And never take your eye off the bottom line.

Mark Bristow
Producer / Writer
BBC/BBC Wildlife Magazine

Asked to write about the future of the wildlife film-making industry and my first thought is ... is there one? And no, it's not unthinkable. Five years ago, and the garden was rosy ... lots of six-month jollies to the Serengeti. Two years ago and it appeared an asteroid had struck and everyone was picking up the pieces, like down-and-outs searching for cigarette butts. Since then, Survival has been scrapped, a number of independents have gone to the wall, and others, including major player HIT Entertainment, have announced a move away from natural history. One reason, among others, is the ratings. Think about it; against *EastEnders, Changing Rooms, Groundforce, Pop Idol, Who Wants to Be a Millionaire, Big Brother* and *The Weakest Link*, what was the last significant wildlife hit?

Well in 2001, there were three: *Blue Planet*, lauded as a quality masterpiece, picked up audiences in excess of eight million; Amanda *'Silent Witness'* Burton and her celebrity outing with bears; and third, but not least, *Steve Leonard's Ultimate Killers*, which kept the makeover shows on their toes with a consistent six million plus.

Obviously that's not all. *Gorillas in the Congo* did moderately well for Brian Leith and won awards. Nigel Marven was okay in *Giants* and is a smash on American satellite, but didn't quite break the ratings in the UK. *Bill Oddie's Days Out* and *Predators* scored reasonably, while *Wildlife on One* and *The Natural World* kept the BBC's wildlife flag flying, but with variable audiences and little impact.

Ignoring all else, and thinking like a television commissioner, let's look at the three high points. *Blue Planet* won plaudits because it represents the

acceptable face of quality TV and helps in the ongoing political struggle to prove television isn't 'dumbing down'. It is traditional picture and narration-led natural history, and there were huge struggles to push the more populist 'How did they make that?' sections at the end, which were included only over strident objections from the BBC's Natural History Unit. Great stuff, but TV companies can no longer afford to spend £1m a programme on a series which took five years to make.

Amanda Burton's 'celebrity with wildlife' is a copy of Tigress Productions' *In The Wild* with everyone from Holly Hunter to Julia Roberts. Good for what's called 'grenade' television · in other words a big explosion or splash in the schedules. But are there enough celebrities?

Ultimate Killers is the model for the way forward. It's a cross-genre show, turning natural history into a sort of quiz-cum-competition show. There's a likeable presenter, some wonderful images, and there's the grand 'reveal' ... which is whatever's the ultimate whatever?

Now, if all this is a bit confusing and you're a keen zoology or entomology student with aspirations to make natural history programmes (this is the background of many wildlife directors) and think making a behavioural film with lovely pictures but no plot is fine, let's put a few things into context:

Television companies, including the BBC, chase ratings. The traditional educational-cum-scientific programme doesn't get them. A few years back that wouldn't have mattered too much because lots of lovely wildlife programmes with no plot were made with lolly from American co-production funding, and could be sold around the world. No longer. The co-production funding is much tighter, much choosier and more demanding. The Americans at Discovery and National Geographic in particular want fresh angles, a plot or a format, like adopt-an-animal week; the ten most deadly snakes or sharks; the hunt for a mammoth; 'live' safaris or wildlife vets in action in the Sahara. This means commissions are harder to come by and the whole industry contracts. If you want to win, it means understanding the way the whole of television works, and an ability to make as good a film about gardening makeovers as about rare bees in Katmandu.

It's not all doom and gloom. Wildlife films aren't going to disappear · there will be one-off quality productions like *Blue Planet*, but only rarely. Celebrity sleepovers with bears and orang utans will continue on and off. Series like *The Natural World* and *Wildlife On One* may survive, but probably on the minority channels and only with a significant overhaul. The real move will be to find populist presenters in a range of entertaining formats combined with some interactive web-linked programming.

In the last two years they've tried out newcomers like Saba Douglas-Hamilton; former nude model Mike Dilger on C5; Steve Leonard; primatologist Charlotte Uhlenbroek and even cameramen like Gavin Thurston. This will continue as outsiders like celebrity gardener Alan Titchmarsh are signed up. The trick for forthcoming programme-makers is

to find a new format with enough drama or interactivity to get people talking. That's the Holy Grail that will keep some, not all, wildlife film-makers going for the next few years.

Danny Bamping
Managing Director
Future Planet Limited

Predicting anything can be hard – the Lottery numbers, the Grand National – 'the wildlife film-making business'! Well I suppose anyone can have a guided view – so here's mine!

Having been within and around this business for about seven years now – travelling, filming and of course going to festivals – I've certainly learnt a lot in many aspects: the history of the business, its current state, the technology and of course the people! The future ... well like anything it's uncertain. Trying to get into to the business can be the hardest thing – but it's the first stepping stone to a career that many people would die for (indeed some already have)!

In order to grasp what is to come next a wider view is needed of the 'media' industry as a whole. There are three key factors, which drive the industry:

1. Viewers 2. Technology 3. Advertising

The way viewers 'view' / 'digest' programmes (or rather 'content') is changing options other than the normal TV option include Web streaming, DVD, 3rd Generation mobile phones ... and in the future – who knows!

Another matter is that the technology is so advanced that now the viewers have the 'choice' to turn off the adverts – completely! This news is not good for the advertisers – or the broadcasters. So the industry has to adapt – and make the necessary changes needed to survive.

Various companies are currently exploring alternative funding avenues right across the board. Some of those are working, some not: either way there certainly seems to be a lot more thinking going into the programming and the content of it – and that can only be a good thing.In terms of how all this affects the wildlife film-making business is, I suppose, anyone's guess to some degree. It certainly opens the door of opportunity in terms of ideas, message and 'interactivity'.

The key aspect is the content of programming, not how it is filmed, who filmed it and how much they made from doing it! This will surely change as the days of 'blue-chip' are almost behind us, and the door is opening for the wealth of stories out there – and the hundreds of people behind them.

Cheap content and consumer Digital Video will form a major slice of the cake – and create more 'real' programming. The larger productions will always be there but to a lesser degree – and probably not shot on film either! I believe that the days are numbered for the way the commissioning process is currently structured. The budgets are becoming so low you're almost better off filming the project yourself! Consequently many people have gone down that route. Retaining some of the copyright can be much more lucrative than getting paid a one-off fee and giving someone a finished product that they have first broadcasting rights to, and can then sell to other channels around the world making a tidy profit at the same time.

Of course this is only possible if you know the right people and the companies behind them. In order to do that, 'networking' is the key. Sending out covering letters and CVs can only get you so far – emailing the same. A website –now you're getting there – but actually meeting people is the only way to move forward in whatever aspect of the industry you want to get into!

In order to take the first steps into the business some sort of education is needed – a film or biology degree would be a great help – but they are practically useless without passion.

Passion is a major aspect of this business and without it you might as well sell ice-cream! To be honest – I live to work – and don't work to live! The reason is to tell stories and convey messages of great importance. The current climate will see a great surge of programmes that maybe ten years ago would never have made it to the commissioning editor's desk, never mind the screen (be it a TV or PC)!

In my opinion, making programmes for general consumption has never been easier, cheaper or quicker! The question is – how can you make a living from it and how can you make sure the right audience watches!

Caroline Underwood
Producer & Director
CBC (Canadian Broadcasting Corporation)

Predicting the future has never been one of my fortes; however, about a dozen times a year I meet people who want my advice on how to 'get into the business', and I've found that this requires some crystal ball gazing on my part. Our business – the making of wildlife films – is one that I approach with some trepidation because the 'rules' are always changing. For every 'rule' (you need a degree in wildlife biology, you have to be a researcher first etc) there always seems to be an exception. The explosion in the number of channels broadcasting programmes has created lots of opportunities, but it has also made earning a living from the making of TV programmes very difficult. However, one of the best things about this business is that there are still many ways to become a wildlife film-maker.

As a producer/director the two things that I look for are an aptitude and an enthusiasm for telling or imagining stories, and an ability to work creatively with images. I am always surprised by the number of hopefuls who sit across from me and who confess that they never have the time to watch wildlife documentaries or any documentaries at all. They seem surprised when I suggest that they could learn a lot by watching what other people do or don't do. Another thing that few seem to have any time for is spending time out of doors – it doesn't have to be somewhere exotic – just somewhere where you can learn the rhythms of nature.

Much to my chagrin, wildlife film-making has been seen for many years as the poor cousin of 'real' documentaries. Animal films, or perhaps I should say films about animals, are often considered to be a logistical exercise with success due in large part to luck and/or an animal handler's skill. I was once told "... after all animals do it naturally – you just need a good cameraman". That has changed, in part, because our story-telling techniques have become more sophisticated and complicated. Truth, accuracy and science now play a large role in most productions, but they are not the only creative elements we can use (eg *Microcosmos*). I think that in the future we will see an expansion of story-telling techniques: everything from traditional blue-chip to the drama of personal stories that use the same techniques and conventions as other documentaries.

For a number of years documentaries have been moving away from the more traditional journalistic conventions: no interference with the subject, balance and a straightforward or cinema verite use of images, sound etc. I think that there will always be a place for classic wildlife docs, however – as they are expensive to produce few people will take a chance with a beginner. Set your sights lower and get some experience with a low-budget series.

One of the big advantages to those trying to get-in-the-door is the accessibility of inexpensive video technology. It is now possible to produce a 'wildlife-short' to help you to convince someone of your budding talent as a wildlife film-maker. A good short (five minutes or less) would definitely grab my attention. It doesn't necessarily have to be technically perfect – just very creative. If a video 'calling-card' isn't your style there is still the traditional route of starting as a contract researcher. If you do get an interview or a meeting with a film-maker be prepared to describe how you would approach a research topic – going to the library or checking out the Internet should only be the beginning of your answer.

This is a business with many opportunities; unfortunately if your interests lie in conservation, or with issues and wildlife, getting started will be a bit more difficult (many would say that this is a serious understatement). In the beginning do anything that doesn't mess with your personal/professional ethics (check out the ethical guidelines developed by Filmmakers for Conservation in the chapter How To Get Started). Ours is one of those businesses where it won't be held against you if you work as a PA or a secretary – being in the right place at the right time is half the battle.

I think that those of us interested in conservation and other environmental issues need to ask ourselves: will the issue – the saving of orangutans for example – really be helped by yet another beautiful film about the species. Perhaps there is another kind of 'wildlife' documentary to be made that will have a much greater chance of saving them and their home. Good luck.

Derek Bousé
Visiting Associate Professor of Media Studies
Eastern Mediterranean University, Cyprus

Passing the Torch – to Whom?
History, Technology, and Generational Transition
in the Wildlife Film Industry

In the 1960s the world of mainstream American cinema – Hollywood movies – was quietly approaching a crisis. Television had cut into viewership, box-office was down; amid changing economics, the big studios were cutting staff, selling assets, and scrambling to diversify (MGM would soon go into the hotel business). Most of the industry's pioneers were either retired or dead – or soon to be. They'd been succeeded by other generations, of course, but the studio system's collapse had meant the collapse also of the only system for cultivating new film-making talent. Amid all the gloom, however, new international markets were beginning to open up, and soon the need for talent, for new blood, seemed poised to outstrip the meager supply coming haphazardly from the industry itself, which was largely in disarray.

Sound familiar? To those of us who watch the wildlife and natural history film industry, the parallels are worth noting. So what happened? How did the mainstream film industry satisfy the new demand not only for talented directors, but for artists and technicians skilled in camera operation, lighting, sound recording, editing, set design, scoring, and the myriad other tasks and skills needed to get films produced?

Enter film schools. New York University (NYU), the University of California at Los Angeles (UCLA), the University of Southern California (USC) and others began graduating students (you know their names) who, by the mid-70s, had begun to transform and even dominate the creative side of the industry.

The wildlife and natural history film industry may well be at a similar stage in its history. Like mainstream cinema, the first generation of wildlife film-makers (Ditmars, Kearton, Kleinschmidt, Pike, Rainey, et al), are all dead. They had got into the field early, when there were no rules, and no competition. They invented the genre. The second generation (Field and Smith, Buck, the Johnsons) had faced an already-formed and competitive industry, to which they responded by developing distinctive styles and market niches (good advice for today's aspiring wildlife film-makers). They

had also negotiated a major technological shift: the transition to sound. The third generation (Cousteau, Denis, Disney, Grzimek, Hass, Perkins, Sielmann, etc.) had largely begun in the cinema, but then became pioneers of wildlife television. It was with the fourth generation, however, that wildlife film experienced a sort of "baby boom" of producers, on-air personalities, and film-maker-camerapersons, too numerous to name here individually. It is this generation that has dominated the scene for over thirty years but that is now, in the early twenty-first century, largely retiring and withdrawing from the scene. From where will the next generations come?

Currently, in the year 2002, the industry is in a downturn. Some of the major production houses, to the surprise of all of us, have been closed down. Others are shifting their focus to other types of non-fiction and documentary production. Nearly all are cutting staff and scaling back their ambitions and expectations. Virtually none is in a position to see to the care and feeding of tomorrow's crop of talent. This all sounds startlingly familiar. Yet if there is a resurgence in demand, and if production increases to meet that demand, and if this amounts to a sort of re-industrialization of the natural history film business, then we may well see a demand for skilled and trained people that only film schools can meet.

I am not proposing that history will simply repeat itself predictably and straightforwardly, but I do think it holds some valuable lessons both for people seeking to enter the industry, and for those working in it now. Currently wildlife and natural history film classes and even degree programs are springing up from Munich to Britain to Montana. Time will tell if this embryonic film school 'movement' becomes as important to the wildlife/natural history film and television industry as it has to mainstream film and television.

But more than time it may be changing economics and technologies that tell. Significantly the current upheaval is all happening at a time of great technological change. Industry standards are in flux. Many young people now stand not with diplomas in hand, but with DV-cams and editing software that allow them to be complete film-makers on their own. And DV, as we all know, is now accepted as an origination format. Yet these seemingly well-equipped beginners face an industry that is more stratified and capital-intensive than ever. What good is DV if the standard becomes HD – or IMAX? The current competitive market has driven budgets way, way beyond what the neophyte, armed with a Canon XL1 and the latest edition of Final Cut, can handle. Technological developments and economies of scale continue to up the ante, making this more of a rich man's game than ever – and looking more like mainstream cinema than ever.

So looking for parallels between the two remains a valuable exercise, and history reasserts itself as a venerable teacher. If the emerging academic programs are able to turn out a few classes of skilled and talented people, and thereby establish themselves as a linchpin in the industry's future, they will be where the action is. IF, that is.

Adrian Caddy
Executive Producer
Indigo Factual Ltd

Wildlife TV – a future...?

Spring 2002, and the TV schedules in Britain are still just echoing to the glory that was *Blue Planet* and *Wild Africa*. These retain the splendour and audience delight that were born in the years that followed full penetration of colour TV and David Attenborough's pre-knighthood masterpieces – *Life on Earth, Living Planet* and the series and singles that they inspired. The BBC Natural History Unit, Survival and Partridge Films were the centres of excellence and their output delighted generations of viewers from all walks of life the whole world over. And I know that from first-hand experience a-plenty.

One of my roles in the 1980s was to licence TV programming internationally – and I had the rights to Partridge Films' output as well as the most popular fiction series ever – *Dynasty*. A European state broadcaster wanted to acquire the rights to *Dynasty* series 6, and I got them to pay a record price for it. The highest fee ever paid for a foreign programme. And to the deal I added a Partridge trilogy – at the same price. very secret and not-to-be-repeated alas, but then I could argue that the content and vital importance of such programming was more deserving of their money than the already over-paid stars of a soap opera were. It worked then, it wouldn't now.

While TV screens, and the limited number of channels that fed them, stayed far and away the most influential single media tool to reach people, the passion and story-telling that prevailed in natural history film-making had an obvious future. Now, only the BBC NHU survives as a corporate bastion in the UK while stout independents display SAS-like fortitude to survive in (temporarily?) lean times.

If there is to be a future in wildlife story-telling and image delivery then the approach to the market and marketing needs to be totally re-thought. Blue-chip may have a future – but not in isolation. I think programming has to move forward like weaponry: not just big and full of presence – but discreet and carefully targeted. More people have more screens and more appetites than they had when David was young, and to reach them a system needs flair and imagination as well as desirable items to deliver.

TV companies don't have the managers with the right flair and imagination because they are in the wrong places and divided. Split loyalties, jealousy and departmentalised lack of knowledge/market intelligence prevent the creativity of wildlife story-tellers moving out of the battleship era and into a time that embraces the rapid deployment of smarter tools. We will need celebrity shows about animals, DV-Cam hand-held shots in bucket-loads, panel games and quizzes and commercial associations that make sense for advertisers and sponsors. And from an unprejudiced mix of talent working as teams, we can deliver to TV, the Web, DVD, video collections and events in the same way that soccer, soaps and pop music do.

The future will carry sponsorship and support from advertisers, properly advised and, I think, surprisingly rewarded as a result of showing the world they care about the generation that trades with them now and those that will grow to. The tactics will be new and untested – as indeed they must have been when black and white pictures first appeared – but the components aren't. Passion, technical innovation, story skills and communication expertise are still key. There are enough of us with the right stuff but the TV companies with their advertisers need to move beyond the musketry mentality and equip for the crucial battles of getting great stories across to an audience who still think we might all have beards, sandals and eat muesli. If we don't or can't embrace commercial support, and discern the right from the inappropriate, then the future of wildlife story-telling could resemble that of coal-mining or ship-building in the UK

Michael Hanrahan
Founder & President
The Ocean Channel, Inc (Ocean.com)

From my perspective, this is a very exciting time to be involved with wildlife film-making. For one, there is a certain sense of immediacy associated with capturing the imagery of a natural world which is increasingly threatened by the heavy hand of man and his overbearing demands on the planet. Many film-makers today are concerned with capturing what may be their last opportunity to film a healthy coral reef, for example, or to capture the endangered Leatherback Sea Turtle on tape. Without being too doom and gloomy, the bottom line is that we are seeing a dramatic

decline in just about every natural system worldwide. This is essentially what motivated me to become a film-maker, so perhaps others considering the trade would be interested in what brought me here.

I studied Marine Science at the University of Miami in Florida. The information I was hearing from my professors on a daily basis – the decline of marine systems everywhere – made me very upset. And yet I was studying to become yet another scientist who researched and studied specific elements of the marine environment, but who was hopelessly incapable of communicating to the masses the ramifications of what I was discovering. I recall very clearly one highly-acclaimed marine biology professor, who was a brilliant scientist, but who had trouble communicating to a lecture hall full of eager students. If this man was having trouble conveying the severity of his findings to us – a group of well-educated students – how then would the message get out to the masses who understood the ocean only by what they could see at the surface? It was the early 90s and the world had not yet begun to recognize the significance of the decline of marine systems across the board.

It was then that I made the decision to become a messenger. I picked up a second major in Motion Picture Film-making and became the first student at the University of Miami to study Marine Science and Film-making concurrently. But this seemed perfectly logical to me. A powerful message was coming out of the marine science community: the oceans are in trouble.

But very few were getting that message. The most powerful means of communication was, at that time, television and I began to study the craft of communication through images, music, and powerful narration. The human brain assimilates messaging extremely efficiently when these three elements are combined in an artful manner. It is this craft that I encourage the reader to study and master.

I went on from the University of Miami to be involved with dozens of underwater productions, working with some of the truly great documentary film-makers like Mike DeGruy, Bruce Reitherman, and Tom Fitz. I was fortunate to have credits with the large, cable broadcasters: BBC, Discovery, PBS, and National Geographic. For five years, I worked hard in the natural history film-making industry until the Jackson Hole Film Festival of 1999 changed the way I thought about the business and my future in it.

Many in the business will remember that afternoon in September of '99. A panel of broadcast commissioners – those individuals responsible for the "green lighting" of new productions for their respective companies – had been assembled for a discussion on conservation messaging in natural history films. The room was packed. There were guppies like me and some of the true legends of the business in attendance, riled up to speak their piece. It was incredible.

The lackadaisical chiefs on the panel informed the anxious crowd that there was little room for conservation messages in broadcast programming. Their

market analysis told them that the public simply does not respond well to shows with an environmental emphasis. The crowd argued with the commissioners, stating that it was our responsibility as the "eyes of the masses" to illustrate in our programmes the truth of what is happening to the natural world. In one heated exchange with a passionate producer from the audience, one of the panelists boldly put it this way: "If you are so committed to this type of programming, find another means of distribution because (company's name) is not going to put it on our channel." A heavy silence fell over the hundreds gathered in that huge room at the Jackson Lake Lodge as everyone absorbed the hard reality of what was being said.

It was in that moment I scratched a note to myself in my spiral notebook: "Consider building an Ocean Channel on the web." Ever since that day, I have been working towards that goal, inspired by that panel meeting and, specifically, the comment: "Find your own means of distribution."

And I encourage you, the reader, to do the same.

There is little question that the natural history film-making industry is amidst a massive change. And although change is inherently unsettling, it is also very exciting. Individuals who seek to be a part of this truly fantastic business of bringing the message of the wilds to the masses face a new frontier. But they are joined there by many veterans of the industry who are having to adapt to a changing landscape. And in my mind, the theme of this changing landscape is 'digital' and the evolving vehicle to navigate this new frontier is the Internet.

The day is coming where the new format of choice – high definition – will be delivered via ultra broadband connections to Internet users around the world at the click of a mouse. Viewers will no longer be constrained by programming schedules dictated by advertisers. Instead, they will select their natural history programmes online at sites like Ocean.com and The Ocean Channel, watching what they want to watch, when they want to watch it. This is the new frontier. And though it is a few years out, it has been my strategy to build for the future. In the meantime, while we wait for the greater population to adopt broadband Internet access, my team at The Ocean Channel has established the architecture to deliver ocean-centric programming today.

Many ask, how do you make money on the Internet? There are many strategies implemented for revenue generation at Ocean.com and The Ocean Channel. Most of them employ cross-platform marketing, an example of which is a streaming programme on Shark Dives of the Bahamas with hyperlinks to the Ocean Travel section highlighting resorts and dive operators in the Bahamas. Increasingly, the option of making "premium" areas of a web site accessible only by subscription memberships is becoming a reality. And original programmes produced by The Ocean Channel for webcast can be compiled for half hour television slots or packaged for DVD sales in the Ocean Store. These are just a few of the many different ways to make money online with your skills as a film-maker.

Bottom line: become familiar with the evolution of the trade. Grasp the fact that the technology is changing everything rapidly: cameras, post-production, distribution, etc. To succeed in this field, you must first and foremost be a good film-maker. But immediately, following that, you need to master the current technology and be on the lookout for the next big evolution. And finally, be passionate about what you do. In times of uncertainty such as we experience on a global level today, the world needs more passionate people – with dedicated messengers shedding light on the beauty of the natural world and the tragedies that increasingly befall it.

Amy J. Hetzler
Membership Officer
Filmmakers for Conservation

Call it what you will – wind of change, a turn of the tide, a migration to a better climate or the spawning of a new generation – the wildlife film-making industry is in for more change. The golden era is over, the technological era is buzzing along and all the while, the beauty and fascination we have with wildlife and wild places is as perennial as the sun.

I believe the future of wildlife film-making includes several exciting new factors. I think digital and particularly, High Definition acquisition will become an even more prevalent format. Certainly DVDs and the Internet will garner more serious consideration related to advertising and revenue opportunities; co-productions will still be the norm; and beautiful stories will continue to abound from the creative minds of writers, producers and distributors around the world. On the sober side of things the pace of the money race will never slow; satellite, cable and broadband channels will make the pie slices ever-smaller; and animals and habitats around the world will continue to be threatened.

The ten years (1990–2000) during which I was involved with the International Wildlife Film Festival in Missoula, Montana provided me an amazing opportunity to view over 1,000 wildlife films. One conclusion I can draw is that they are produced for three reasons: love, communication of information, and (sometimes) money. The ratio of the three elements can vary widely and it is interesting to note that the 'magic factor', or love, invested in a film is sometimes very obvious. That factor drives many of the people I've met in the past twelve years.

Wildlife film-making has changed forever in the past ten years. One way is

that many animals featured in films these days are wearing collars, earrings, tattoos and even transmitter chips and cameras. Another is simply the way storylines have been forced to evolve. Rather than visiting a wild, 'undiscovered' location to observe and learn the natural history of the creatures that live there now we are learning that wildlife populations are endangered and habitat is, without check, being destroyed, and the competition for living space between humans and animals is keen. These things illustrate all too clearly another way the industry has changed forever – some of the pristine locations featured in films in the 1990s are gone. What will wildlife film-making be ten years from now? The answer is impossible to know, but you can bet it will be different.

TV broadcasters and advertisers could help the conservation and environmental movement around the world · why not? Why not let there be a hard-hitting E-channel, for high-quality, up-to-date coverage of current affairs, world events and news about our planet? That's part of the future I'd like to see happen in our industry. Blue-chip will die only if the animals do – perhaps a metaphor for recent history. Presenter-led is probably here to stay, and clearly, some folks are better at it than others. Broadcast being the ultimate goal of your work means finding ways to tell your story in defined time slots, within a template of guidelines. Be prepared to compromise.

My opinion about the future of wildlife film-making includes the knowledge that the playing field is more open than ever before. Digital video cameras make it possible for anyone, anywhere in the world to consider him/herself a film-maker. Lowered standards and budgets from the broadcast end of things further opens the field, so the competition is keen.

Technologically-speaking, I think digital is absolutely the way to go. Gear and editing systems available today are astounding in their abilities and price, especially when compared to some of the dinosaurs out there. I will not argue that film is not a beautiful format. But if you are just starting out on a modest budget, a digital system puts all the tools you need in your hands. You can upgrade components as you go. Broadband and the Internet present an awesome opportunity. I encourage any newcomer to learn the basics of digital media technology as associated with the Web.

Two important things that will assist you in many of your endeavors – meet people and create relationships; but also be careful about choosing partners. Amazing friendships and relationships can be created by attending festivals and that has helped me endlessly. Find a mentor and an e-penpal or two – these people will help you monumentally. It also pays to know who's who and to know about people's work so read, watch television and watch films when you can. As with any industry, the wildlife film-making business is full of wonderful people with kind, generous souls as well as scoundrels, so keep a wise perspective.

Hardy Jones
Executive Director
BlueVoice.org

To ascertain the future of wildlife and natural history film-making we must define the context in which we all live, and in which such film-making will take place. We live in a world where the vast majority of large land mammals have been reduced to pathetic fractions of their original number, most of the great whales are now at some two percent of their pre-hunting populations, large areas of coral reef are dead or dying around the world, and global warming and destruction of the ozone layer threaten the very biosupport mechanisms of our planet.

While there are many film producers who document the truth of the ongoing destruction of our planet, many do not, choosing instead the more lucrative and pleasant task of filming in ever-diminishing islands of paradise, where the nastiness of humanity's impact on the planet can, for the moment, still be screened out.

Such filming is analogous to putting a camera on the sticks in Germany during the 1930s and making charming films about quaint people in lederhosen waving steins of beer. Sure, that happened in Germany during the 1930s but something enormously sinister was also happening in plain sight, something which would soon engulf the world in conflagration and cost tens of millions of human lives.

Anyone making a wildlife or natural history film which ignores the impact of the greatest predator, pollutor and habitat-destroyer, is guilty of a true disservice. We are at a critical juncture in the history of the world. We may still have time to reverse the effects of our folly but with each day that passes we sink deeper into the quagmire. Dr Stephen Schneider of Stanford University, one of the world's most respected climatologists, recently told me "It is not whether global warming will occur or sea levels will rise, it is exactly when and how much, and that is a function of how long we wait to take remedial action."

We must make hard choices now and anyone with access to the media, either on the production or the transmitting side, who misrepresents the level of crisis we face is doing a disservice to life on earth. Anyone making a

film about Thailand without showing the devastating deforestation is misleading us about a matter of life-and-death importance. The same must be said about coral reefs which are dying worldwide, killer whales whose bodies contain toxic levels of industrial chemicals, or sharks, whose populations are being decimated to provide shark fin soup.

A recent encounter illustrates this point. I was attending a fundraising cocktail party in Silicon Valley. Wealthy delegates were being urged to make a contribution to an ocean conservation organization. Some facts and figures were offered about the decline in fish stocks worldwide, levels of pollution and habitat destruction in the marine environment. One of the guests, a highly intelligent and enormously wealthy man who had founded one of the most popular search engines, expressed surprise to me. "I just saw *The Blue Planet* the other night and everything seemed absolutely wonderful. Every story teemed with life and vitality. And that was the BBC, perhaps the most reputable authority on earth: so what's the problem?"

The only relevant question we can ask about the future of wildlife film-making is, "What is the state of the natural world and its animal populations in which we are making films?" and, "Am I using my talents and abilities to address what is literally a threat to life on earth, or am I enjoying the greatest job on earth in isolation from all the facts?"

It's nonsense to say that programming about threats to the environment is boring or causes people to reach for the remote control. Pedantic diatribes don't work but adventurous stories about dedicated people fighting the battle to save species and ecosystems – ecosystems on which our lives depend – can be made to work through a partnership of film-makers, distributors and broadcasters.

The alternative is that wildlife film-making will be reduced to well-deserved irrelevance, joining cop shows, cartoons and sports in distracting us from the difficult choices society must make.

...

Thanks to all the contributors for their views.

Finally it is time for **My Two Cents!**

Through producing Wildlife Film News I get to communicate with a lot of wildlife film-makers from all over the world on a daily basis. What I have been hearing a lot of recently (and also pick up from wildlife film festivals) is doom and gloom, jealousy and pessimism – all negative sentiments that achieve nothing. If you were earning a great living, and having a great lifestyle, making wildlife films, then suddenly you aren't, then of course you would not be happy about this. But moaning will get you nowhere. The industry is changing – so change too. If you do it with creativity and wisdom it doesn't have to mean 'dumbing down'. Sit back and wonder where the good times went and you will be pushed aside by all the young enthusiastic

newcomers with great new ideas and energy.

Think of it in terms of evolution – ADAPT TO SURVIVE – continually...

Business will always be up and down, so learn to accept and expect that. And remember always to consider what you do as a business – if 'sales' are poor then you need to rethink your product and/or your marketing. You may need to look at diversification ·producing films not just for television, but also for multimedia, education, and other offshoots.

Ignore the Internet at your peril! Broadband is not a future dream – it is here now – so increasing numbers of people around the world are able to download and view high·quality interactive programmes whenever they want. Think about the implications of that. Not so long ago (in the UK for example) if there was a big budget, blue·chip natural history extravaganza on BBC1 then of course it got good ratings! Not only was it the only wildlife programme on at that time, but there were only two or three other channels to choose from. But choice via satellite/cable/Internet is growing all the time, so productions have to change to suit. Interactivity on television and moving images on the Internet are diverging. I'm not saying there is no longer a place for the big blue·chips – but I believe variety is the key. Big· budget films and series, properly marketed, will still be successful, but will be only one of many products from wildlife film·makers. Variety is the spice of wildlife!

Another bee that has been busily inhabiting my bonnet for some time is that I hear a lot of criticism of certain TV programmes that are very popular at the moment. I might not endorse the particular style but the point is to learn from another's success not just to sour grapes it. Too many wildlife film producers think like – well, wildlife film producers – in other words they are nuts about wildlife and appreciate high quality films – but the general public is not (necessarily) like that. A key goal is to think like the public. When there is a good choice of channels you can't argue with ratings – try to analyse what makes programmes popular and weave that into your formula. That doesn't mean you suddenly have to have presenters handling animals to be successful – but with creativity and intelligence you can learn – and adapt – and survive. There needs to be more dialogue with the general public about what they like to watch.

Finally I would like to write a bit about conservation on TV. I have been passionate about conservation ever since I was a child, and it was watching wildlife films that made me passionate. Something in my nature has given me a great respect for life, and so I was incensed to discover (for example) that thirty years ago rhinos were being slaughtered in Africa merely for their horns. It was (and is) simply absurd. Imagine how I feel now that this slaughter has increased many·fold since then – within my lifetime! Somehow I thought that once the 'world' knew about the problem (through television) that somehow it would be sorted out. How wrong I was.

What does this mean? That knowing about a problem isn't enough? That

conservation films are ineffective? Let's face some facts – we are privileged to be wildlife film-makers – and we are partly (maybe largely) responsible for educating the world about natural history. So are we not making a major mistake if we do not tell the truth about the state of the planet for the sake of ratings? I'm not saying that every film should be a depressing depiction of man's destruction – again variety is the key. Some portraits of wildlife/habitats do not need to mention man-made problems at all – but in general the public is led to believe that everything is still OK out there in the natural world that they rarely see. Well, it isn't.

In fact I'm not saying that any film should be a depressing depiction of man's destruction – who wants to watch that? I'm sure with the skills and talent we have in this industry we can make films that educate, entertain and inspire change. Films that tell it like it is, but focus on the solutions rather than the problems in an uplifting and positive way. Films that make the viewers feel good about what they can achieve in making this a better world, rather than depressed about what it has become.

If you make money from wildlife films then to a certain extent you are exploiting the wildlife – and the habitat/country/local people. Surely helping to ensure their conservation is the best way you can repay them? Furthermore – we rely on the future of the natural world for the future of our industry – how can we turn our backs on its destruction while we reap the short-term rewards? I have been dismayed and shocked at the lack of interest in conservation shown by the majority of wildlife film-makers. It's time we grew up, stopped being another selfish cog in the machine, and took responsibility for our position as global educators for the natural world. It really is that important.

OK – I've had a cold shower and calmed down a bit now... So how are we going to do this? I've already spoken about making positive, watchable shows that make the viewers feel good – even if they are about problems. And if you make the viewer feel good they're going to want to watch more, and that can only be good for ratings...

We also need to show the viewer how the problems affect them – most people aren't worried about global warming because the only effect they expect is that they may get a better tan! We need to link it all together – and local productions about local wildlife/conservation issues will be a part of this – films don't always need a large audience to be worthwhile.

In addition we need to give viewers a way to react/respond/get involved. After all it is them we are trying to inspire – how can we leave them full of enthusiasm but with nothing to do about it? The enthusiasm will fade rapidly as they get on with their post-your-amazing-film lives. One way of ensuring follow-up is to have a weblink address throughout each programme (in fact I think every wildlife film should have an associated website). The end credits should also include a variety of ways to get in contact for those (few) who don't have Internet access. The associated website should give further information about the film/project (good for marketing in any case), and a

variety of ways the viewer can get involved. Some like to sign a petition, others like to send money, adopt an animal, join an organisation, take direct action, make lifestyle changes, buy a book, buy a video copy and so on. Integrate, communicate, and make a difference – you are truly in a unique position to achieve this!

Well, that's it! I do hope you find this book a useful ally in your quest to be (and stay!) a wildlife film-maker. The challenge is there – seize it.

Good luck!

Contributors' Index

Many thanks to the following contributors to this book. Here you will find their contact details and a bit more about what they do. Please do not abuse these contacts; they are busy people who have already given their time to advise you. Note that the '+' on the phone numbers requires the international access code which is usually 00, and numbers in brackets eg (0) would be omitted if dialling from abroad. Contributors are listed in alphabetical order of surname:

(Many of these contacts are from 2002 so not all will still be valid...)

Doug Allan
Phone: + 44 (0)117 973 7579
Mobile: + 44 (0)787 603 2608
Email: dougallan@blueyonder.co.uk
Website: www.dougallan.com

Award-winning topside and underwater cameraman, wildlife and scientific documentaries. S16 & Digibeta housings. 15 years experience, particularly in the polar regions but many other remote parts of the world.

Victoria Arlidge
Making Tracks
Website: www.makingtracks.uk.co

The best in original music soundtracks and sound design. Composing a perfectly constructed music soundtrack, accurate to period, nationality and style. SMPTE time code enables us to time our music to a 25th of a second, perfectly complementing visuals. As instrumentalists we believe that the use of 'real' instruments is far superior to the synthesised alternatives and will use the best session musicians to produce a higher quality composition, no matter what the budget.

Martin Atkin
Greenpeace International Video Production Unit
Keizersgracht 176, 1016 DW Amsterdam, Netherlands
Phone: +31 20 524 9544
Email: martin.atkin@ams.greenpeace.org

Greenpeace is an independent campaigning organisation that uses non-violent, creative confrontation to expose global environmental problems and to force solutions which are essential to a green and peaceful future.

Daniel M Bamping
Future Planet Limited
5 Hillside Ave, Mutley, Plymouth, Devon PL4 6PR UK
Phone: + 44 (0)1752 664544
Mobile: 07831 658492
Email: danny@futureplanet.co.uk
Website: www.futureplanet.co.uk

Future Planet is a specialist production company that utilises its unique skills and knowledge in the expanding markets of natural history, environmental and underwater imaging. Our main area of activity is the origination of specialist filming requirements for broadcast television, which includes producing programmes for local, national and international broadcasters and satellite channels.

Jeffery Boswall
Wildlife Television Training
Birdswell, Wraxall, Bristol BS48 1JZ UK
Phone/Fax: +44 (0) 1275 853418
Email: jeffery_boswall@hotmail.com

Jeffery Boswall was a BBC Natural History Unit television producer for 24 years. He then ran the film and video unit of the RSPB for 6 years before being appointed a senior lecturer in wildlife TV at the University of Derby. He is now a freelance presenter of wildlife/environmental film/video programme-making courses and has taught them in UK, USA, Latvia, Estonia, Italy and elsewhere.

Derek Bousé
Email: dbouse@hotmail.com

Derek Bousé earned his Ph.D. from the Annenberg School for Communication, at the University of Pennsylvania, in Philadelphia. He is currently Visiting Associate Professor of Media Studies, Eastern Mediterranean University, Cyprus. His book Wildlife Films is published by the University of Pennsylvania Press (2000).

Mark Bristow
BBC/BBC Wildlife Magazine
Email: mark.bristow@bbc.co.uk

Entered newspapers by interviewing Snow White and some of the seven dwarfs trapped on a snowbound train at Sevenoaks Station. Freelanced in newspapers before running four titles in Kent. Environment Correspondent on The South Wales Echo before researching the BBC environment programme Nature, followed by State of the Ark (a series on European zoos). Most recently series produced DIY SOS and Countryfile. Writes monthly preview page for BBC Wildlife Magazine.

Karen Brooks
Facilitation Southern Africa
52 Eleventh Street, Orange Grove, Johannesburg 2192 South Africa
Phone: +27 11 485-4020
Fax: +27 11 640-1642
Mobile: +27 83 259-6324
Email: kbrooks@netactive.co.za
Website: www.welcome.to/facilitation-sa

Shooting in southern Africa? I offer professional, cost-effective location fixing with an extra special personal touch. I don't know the meaning of the word "impossible". So whether it's the full service, from sourcing stories to arranging an itinerary, entire crew and equipment – or just a "meet and greet" – let me handle it for you.

Beverly Brown
Beverly Brown Wildlife Films
9 Ethel Street, Wakari, Dunedin, New Zealand
Phone: +64 (0) 3 476 2044
Email: bevbrown@paradise.net.nz

A very professional producer and writer with a lot of experience, and a broad range of creative and practical skills. Although happy to work in traditional ways, anything unusual or innovative interests me. If you have an idea to toss around, I'd be pleased to help.

Adrian Caddy
Executive Producer and Head of Science and Nature at Indigo Factual Ltd
116 Great Portland Street, London W1W 6PJ UK
Phone: +44(0)207 612 1701
Fax: +44(0)207 612 1707
Email Caddyap@aol.com

James Chapman
Researcher/Assistant Producer
Imago Productions
5th Floor, Grosvenor House, Norwich, NR1 1NS UK
Email: james@imagoproductions.tv
or: jameschapmanuk@hotmail.com
Website: www.imagoproductions.tv

Formed in 1997 Imago is now the largest independent producer in the East of England with 20 staff and 3 in-house off-line and on-line edit facilities, we are an established supplier of popular factual programming for international and UK markets. In 2001 Imago expanded its creative output into new media and interactive television and more recently has expanded into corporate production by applying its creative and innovative ideas to the commercial market.

Brendan Christie
RealScreen
#500, 366 Adelaide St West, Toronto, ON M5V 1R9 Canada
Phone: +1 416 408 2300 X444
Fax: +1 416 408 0870
Email: bchristie@brunico.com
Website: www.realscreen.com

RealScreen is an international monthly magazine completely devoted to non-fiction programming. From production, through distribution and broadcast, including suppliers and technology, RealScreen devotes its attention to all factual genres. Don't miss our annual Natural History Guide, available every September.

Peter Crabb
Email: films@blueplanet-productions.com.
Website: www.blueplanet-productions.com

Peter Crabb of Blue Planet productions can provide: assistance with all outdoor filming in New Zealand, Australia, sub-Antarctic and the Pacific Islands. I am available to help international crews with wildlife stories with a speciality in underwater work.

Rosi Crane
NHNZ Stockshot Footage Library
PO Box 474, 8 Dowling Street, Dunedin, New Zealand
Phone: + 64 3 479 9799
Fax: + 64 3 479 9917
Email: rcrane@naturalhistory.co.nz
Website: www.naturalhistory.co.nz

Over 4,000 hours of stockshots gleaned during 25 years of documentary making, covering natural history, adventure, archaeology, science, medicine, underwater and travel genres. The library staff bring expertise to your project, by making suggestions, by meeting deadlines and by negotiating deals. Location footage encompasses the entire Pacific Rim, Antarctica, Asia, South America and East Africa.

Hazel Cripps
Researcher / Production Coordinator
Imago Productions, 5th Floor, Grosvenor House, Norwich, NR1 1NS UK
Phone: +44 (0)1603 727612/600
Fax: +44 (0)1603 727626
Email: hazel@imagoproductions.tv
Website: www.imagoproductions.tv

Formed in 1997 Imago is now the largest independent producer in the East of England with 20 staff and 3 in-house off-line and on-line edit facilities, we are an established supplier of popular factual programming for international and UK markets. In 2001 Imago expanded its creative output into new media and interactive television and more recently has expanded into corporate production by applying its creative and innovative ideas to the commercial market.

Larry Curtis
Curtis Photography, Inc., P.O. Box 900, Naples, Florida 34106 USA
Phone: +1 941-596-7377
Email: curtisfoto@aol.com
Website: www.curtisfilms.com

Larry Curtis/Curtis Photography Inc. is dedicated to the acquisition of highest quality underwater imagery. Working in 35mm still photography, DVCAM, S16 film and the exciting new High Definition format, his libraries include many subjects ranging from marine mammals to current marine issues. Please contact him for a complete updated stock list and travel itinerary.

Mark Deeble and Victoria Stone
Old Coastguards, Gurnards Head, Zennor, St. Ives, Cornwall TR26 3DE UK
Phone: +44 (0)1736 796978
Fax:+44 (0)1736 798292
Email: deeblestone@aol.com, crocodile@hf.habari.co.tz

Mark Deeble and Victoria Stone are based in the UK and East Africa. Both experienced divers and pilots with topside and underwater skills, their films have won them over 90 international awards including a Peabody and 'Best of Festival' at Wildscreen, Jackson Hole, and Japan. Facilities include Avid edit suite.

Charles Denler
LittleRiverMusic
P.O. Box 12, Marlborough, CT 06447 USA
Phone: +1 860-295-8081
Email: charles@LittleRiverMusic.com
Website: www.LittleRiverMusic.com

Charles David Denler's award-winning music can be heard all over the world on programmes such as National Geographic and PBS. Charles is also a sought-after speaker, leading film scoring workshops and also giving seminars on ancient music.

Matthew Drake
62 Killyon Road, Clapham, London, SW8 2XT UK
Email: mpdrake@hotmail.com

I am a hard working camera assistant with aspirations to become a camera operator. I have acquired a wide range of skills, and have built up a good technical and practical knowledge of broadcast equipment, relating to film, video, and sound-recording. I have a deep-rooted fascination with the natural world that has fuelled my ambition to become a wildlife cinematographer.

Jeremy Evans
25, Cliftonwood Crescent, Bristol, BS8 4TU UK
Phone: +44 (0)117 914 5737
Email: jeremyevans@blueyonder.co.uk

Award-winning writer and executive producer – films such as The Great Dance and The Global Detective have won Golden Pandas at Wildscreen, and awards at the IWFF and Jackson Hole. His 2 hour special Endurance:Shackleton was nominated for the BAFTA documentary award. He is a former Editor of BBC Nature. Recent clients include the BBC,C4,TLC.

Nick Gordon

Nick was a seasoned 'extreme conditions' film-maker, presenter and author. Although he has filmed all around the world, the Amazon rainforest has been his home continuously for more than ten years. During that time he made eight one-hour TV specials for Survival and worked on several BBC series. Books by Nick are available direct from his web site.

Since this book was first published in 2002 Nick tragically died of a heart attack while filming spiders in Venezuela in 2004. Sadly missed by many.

Michael Hanrahan

President
The Ocean Channel, Inc.
P.O. Box 765, Carpinteria, CA 93014 USA
Email: michael@ocean.com
Website: www.ocean.com

The Ocean Channel, Inc. is a new-media corporation based in Santa Barbara, CA USA. Its focus is the aggregation, production and distribution of premium ocean content for a diverse array of media, including television, radio, print, and the Internet. The Ocean Channel, Inc. was founded in April of 2000 as a registered California corporation and seeks global partnerships.

Rob Harrington

Redeeming Features International
Phone: +44(0)1508 495467
Email: rob@redeeming-features-international.com

Rob Harrington travels widely to edit, supervise and re-version films for the international market. This involves extensive knowledge of script writing, soundtrack laying, dubbing and composing music. He has worked in 35mm feature films and television on all types of programme, from fast turn-around current affairs & sport to classic wildlife, arts and drama-documentaries. His editing experience has proved useful when working as a film composer as he understands how music fits in to a multi-layered soundtrack to produce the best result.

Jean Hartley

Viewfinders Ltd,
PO Box 14098, Westlands, Nairobi, Kenya
Phones: +254 2 583582, 580869, 581157, fax 580424
Mobiles: +254 72 516039 and 733 741167.
Email: viewfinders@net2000ke.com
Website: www.wildlife-film.com/viewfinders

Viewfinders Ltd offers the complete service for documentary film-makers in Eastern Africa. All permits and permissions from the Ministry of Tourism & Information, the Department of Immigration, the Kenya Wildlife Service, National Museums, Railways etc. All accommodation and transport including international and domestic flights, air charters, hire of equipment and local crew.

Amy Hetzler

Former Executive Director of the International Wildlife Film Festival and recently-retired Co-founder of RAT Studios.

Mike Holding and Tania 'TJ" Jenkins
AfriScreen Films
Suite 435, Private Bag X033, Rivonia, South Africa 2128
Phone.: +27 11 708-3576
Fax: + 27 11 708-1373
Mobile: +27 82 412-5963
Email: tjdirect@afriscreen.com
Website: www.afriscreen.com

AfriScreen Films is a high-end natural history production and facilitation company specialising in African wildlife. The team brings together many years of broad international film production experience and specialised wildlife knowledge to provide a fresh, organised approach to producing wildlife films. Our background is based in feature film, television drama series and corporate production – experience that we combine with our wildlife film-making expertise, and our practical experience of working in remote regions.

Hardy Jones
Executive Director
BlueVoice.org (USA)
Phone: +1 707 769-0708
Email: hardyjones@atbi.com
Website: www.bluevoice.org

Hardy Jones has specialized in filming marine mammals for twenty-five years. Using especially designed acoustical equipment he's documented spotted, spinner and bottlenose dolphins, killer whales and sperm whales. Bluevoice.org is working to end the killing of dolphins in Japan and to expose the levels of chemical toxins in marine mammals worldwide.

Joe Knauer
Magic-Sounds
Phone/fax: +43 2242 311 61
Mobile: +43 664 11 22 132
Email: joe@magic-sounds.com
Website: www.magic-sounds.com

Magic-sounds is my company – it´s a one-man show and my motto is: "Recording The Impossible"! Primarily I´m a sound recordist with a full sound kit, but my skills reach from being an assistant cameraman up to rope-work or repair of whatever!

Miranda Krestovnikoff
24, Elmgrove Road, Redland, Bristol BS6 6AJ UK
Phone: +44(0)117 9441996
Fax: +44 (0)117 3771880
Mobile: 0777 330 7535
Email: mizk@blueyonder.co.uk
Website: www.mirandak.co.uk

Miranda is wildlife and science presenter with a degree in zoology and 7 years' research experience in wildlife film production. She turned her hand to presenting 3 years ago. A bit of a generalist, she enjoys a challenge and has a passion for anything watery. TV Credits include Smile for CBBC, World Gone Wild for Fox Television, and the RTS award winning Water Warriors for Carlton.

Jane Krish
Chief Executive
The Wildscreen Trust
PO Box 366, Bristol BS99 2HD UK
Phone: +44 117 915 7101
Fax: +44 117 915 7105
Email: jane.krish@wildscreen.org.uk
Website: www.wildscreen.org.uk

The Wildscreen Trust aims to educate the public about the natural world – to raise awareness about its importance in the hope that people will conserve it better. It does this by promoting excellence in wildlife film via the biennial Wildscreen Festival and by creating ARKive, a Noah's Ark for the on-line era, creating the world's first centralised library of digital images and recordings of endangered species.

Alastair Lawson
Alastair Lawson Productions – Developers of Interactive CD-ROMs / DVDs
P O Box 37 Halfway House, 1685 SOUTH AFRICA
Phone: +27 11 805-1666
Email: alastair@alp.co.za

ALP is a well-established producer of wildlife documentaries, media marketing of exclusive game lodges and educational programmes. ALP's speciality is to shoot wildlife footage and develop the material into interactive CD-ROM and DVD productions for distribution. If you already have completed video material, ALP will gladly develop your footage into a DVD or CD-ROM project, to your requirements.

Brain Leith
Scorer Associates, 10 Redland Terrace, Bristol BS6 6TD UK
Phone: +44(0)117 946 6838
Email: bleith@scorer.co.uk or brianleith@blueyonder.co.uk

Scorer Associates is an independent production company making wildlife as well as music, arts, religious and travel programmes. Christine Owen is Managing Director, and Mischa Scorer, Jonathan Stedall and Brian Leith are the directors.

Jordan McRickus
Imago Productions
5th Floor, Grosvenor House, Norwich, NR1 1NS UK
Phone: +44(0)1603 727605
Fax: +44(0)1603 727626
Email: jordan@imagoproductions.tv
Website: www.imagoproductions.tv

Formed in 1997 Imago is now the largest independent producer in the East of England with 20 staff and 3 in-house off-line and on-line edit facilities, we are an established supplier of popular factual programming for international and UK markets. In 2001 Imago expanded its creative output into new media and interactive television and more recently has expanded into corporate production by applying its creative and innovative ideas to the commercial market.

Mike H Pandey
Riverbanks, New Delhi, India
Phone: + 91 -11- 621 6508 and + 91-11-641 0684
Email: wildlife@vsnl.com or wildlife@ mantraonline .com

Producers of wildlife environmental and adventure series, Riverbanks is today a fully equipped state of art film production and post-production facility. Riverbanks also offers shooting facilities and a base for crews and units coming in for shoots from overseas. Technical facilities and crews are also available. (Winners of Wildscreen Panda Awards 1994 and 2000).

Malcolm Penny
Freelance
The Old Tavern, Union Road, Smallburgh, Norfolk NR12 9NH UK
Phone and fax +44(0)1692 535405
Email: m.penny@eurocomputers.co.uk

Experienced script-writer (ex-Survival, Oxford Scientific Films, HIT Wildlife) and narrator (ZDF, ORF, BBC, Afikim, SET Productions). Recent credits: Cry of the Wolves, 1-hour, Afikim Productions, 2001; Messengers of the Spirits, 1-hour, ZDF, 1999; A Century of Terrorism, 4 x 1-hour, SET Productions, 1998. Scripts mainly wildlife, travel, environmental; historical and geographical subjects also welcome.

Emma Ross
Freelance
Email: ejkross@hotmail.com

Freelance Assistant Producer/Producer with over 5 years experience in the industry. Specialising in wildlife, science and adventure documentaries. Fluent in French and Spanish. Experience and contacts in the UK, Australia, South America, Madagascar and Thailand.

Bryan Smith
Executive Vice President, Programming and Production
National Geographic Channels International
1145 Seventeenth Street, N.W., Washington, D.C. 20036 USA
Email: DocProposals@ngs.org

National Geographic Channels International brings adventure, exploration, culture, science, wildlife and natural phenomena to life for those curiously passionate about the world around them. National Geographic Channels International provides a window on the world, connecting the global community through its entertaining, educational and engaging documentary programming.

Yusuf Thakur
P.O.Box 26425, Sharjah, United Arab Emirates
Phone: + 971 6 5565183
Email: vfx@emirates.net.ae or yusufwings@hotmail.com

Yusuf Thakur is a film-maker based in the United Arab Emirates. He heads Visual Effect & Graphics, a project studio based in the United Arab Emirates, which has two Digisuite-based non-linear editing setups and a separate Motu + Yamaha Audio Studio with a sound booth. The Studio also has a Beta-SP Camera and 16 mm Arri BL, both the cameras can be mounted with Nikon SLR lenses (100-500-mm zoom and 1300mm) used for wildlife work. As a film-maker and studio we are ready and equipped to work with film-makers, on any mutually beneficial projects.

Caroline Underwood
Producer – The Nature of Things
Canadian Broadcasting Corporation
P.O. Box 500, Stn.A, Toronto, Ontario, M5W 1E6 Canada
Phone: +1 416 205-6894
Email: caroline_underwood@cbc.ca

I have spent the past 20 years working as a freelance and contract producer, director, writer and researcher with the Canadian Broadcasting Corporation's science series The Nature of Things with David Suzuki. I am president and founding member of Filmmakers for Conservation.

Chris Watson
Hoi Polloi Film & Video
50 – 52 Close, Newcastle-upon-Tyne NE1 3RF UK
Email: chrisw@filmcrew.co.uk
Website: www.filmcrew.co.uk

Within the partnership at Hoi Polloi, Chris Watson is a sound recordist with a particular and passionate interest in recording the wildlife sounds of animals, habitats and atmospheres from around the world. As a freelance recordist for film, tv & radio I specialise in natural history and documentary location sound together with track assembly and sound design in post-production.

Simon Willock
Head of Factual
Southern Star
45-49 Mortimer Street, London W1W 8HX UK
Phone: +44(0)20 7636 9421
Fax: 020 7436 7426
Email: swillock@sstar.uk.com
Website: www.southernstargroup.com

Southern Star is an integrated film and television production, distribution and manufacturing group. Divisions of the company are involved in film, television and video production: video and optical disc duplication: sales and distribution and licensing and merchandising. Southern Star is a publicly listed company.

Jessica Wootton
68 Greyhound Road, Kensal Green, London NW10 5QG
Email: Jessica_Wootton@hotmail.com

Assistant Producer/Writer. Born & brought up in Kenya. 6+ years experience in natural history and science television production, most recently for Granada Wild. Key experience: research, setting up & directing domestic and foreign location shoots. Directing offline, online & seeing programmes through all aspects of post-production. Programme development & writing

About the Author

Piers Warren is well known throughout the wildlife film-making industry as the editor of Wildlife Film News and producer of wildlife-film.com. After a period as a science teacher he entered the media-world as a musician and sound engineer, eventually running his own recording studio. Although he has experience in many aspects of film-making he specialised in multimedia productions through his company, Wildeye, before concentrating on training. He has written several books and in 2001 was a final judge at the International Film Festival in Montana, USA.

With a strong background in biology, education and conservation, he has had a lifelong passion for wildlife films and has a wide knowledge of natural history. He is one of the founders of the international organisation, Filmmakers for Conservation and was Vice President for the first three years. Wildeye is now known as the world leader in providing independent training for aspiring wildlife film-makers.

Lightning Source UK Ltd.
Milton Keynes UK
UKOW07f1824081214

242841UK00009BA/655/A

9 780954 189938